LOOK INTO MY EYES

how to use
hypnosis to
bring out the
best in your
sex life

by Peter Masters

greenery press

Cover design: DesignTribe, San Francisco, www.designtribe.com

Published in the United States by Greenery Press, 1447 Park Ave., Emeryville, CA 94608, www.greenerypress.com.

ISBN 1-890159-28-X

Contents

Introduction

I WANT to start out with a few reassuring words. Hypnosis is not magical and it doesn't require any special powers. No special crystals are needed, no piercing eyes, no drugs. It doesn't leave you "weak-willed" and it doesn't make you the helpless puppet of the person who hypnotized you. You cannot be hypnotized secretly.

The only things that you need to be able to hypnotize someone are *practice* and *commitment*. Maybe surprisingly, to be able to be hypnotized deeply you also need these same two things. Why? Because you have to learn to really focus your attention on the person who is hypnotizing you, and you need to learn to relax your mind. Most people can be hypnotized to a greater or lesser degree; how much largely depends on experience, on how much you are prepared to relax and let go at the time, on your relationship with the person hypnotizing you, and on their ability.

What I want to do in this book is to give you a good understanding of what hypnosis is – and also what it also isn't – and show you how you can use it in your sex life. It is often said that the mind is the biggest erogenous zone, and I'm going to look at how you can use hypnosis to create and enhance fantasies, to enhance fun and sexy role-playing, to focus the mind for control of sexual responsiveness, and more.

This is not a therapy book. If you have an unhappy or broken sexual relationship then don't expect this book to fix it. It won't. Don't expect that you will learn anything about stage hypnosis or putting on shows – XXXX-rated or otherwise – with this book. You also won't find anything here that will tell you how to pick up members of the appropriate sex and get them to go to bed with you. If that's what you're after put this book away and go get a life.

Hypnosis is not for the weak-willed or weak-minded. The goal of this book is to show you how you can use hypnosis with your partner to create a stronger, more sexual relationship. I'll show you how to use hypnosis to focus the strengths of your mind and your partner's mind. The stronger your minds are, the better the result.

Hypnosis tends to stay somewhere in the public consciousness in a number of ways:

1) Advertisements: Stop smoking, lose weight.

Using hypnosis to help someone stop smoking, or to give up some other "bad" habit, is a good example of what this focus that I was talking about can achieve. With a trained hypnotherapist someone can learn to focus their own strength of mind into the overcoming of a possibly strongly ingrained habit.

Hypnosis is used to "tip the balance" when the person already wants to give up their habit. Hypnotherapy gives the desire that little extra bit of *ooomph*.

2) Movies: evildoer coerces victim to perform dastardly deeds.

This is one of the things that gives hypnosis a bad reputation. In reality it would take a serious long-term program of brain-washing – not just hypnosis, but drugs and psychological abuse – to get someone who is not normally criminally inclined to become a criminal.

Hypnosis doesn't change someone's fundamental nature. It's an individual's upbringing and the major events in the lives that shape them. Hypnosis can only reveal what may be hidden, but is already there.

3) News: police use hypnosis to help a witness remember details.

I like this use of hypnosis. This shows one of its really basic characteristics: the focus of concentration. When the police use hypnosis

to help a witness remember details of a crime, the technique involves helping the witness clear their mind of distractions so that the memory can float to the surface unobstructed.

A witness cannot remember something that they never heard or saw, but sometimes there is so much debris – like emotion or fear or even other memories – that the detail which the police need just cannot come out. Hypnosis lets the witness exclude all these other bits and pieces so that the wanted detail can emerge.

4) Stage-shows: Joe and Jane Public do embarrassing things to make you laugh (c'mon! surely they knew that they'd be acting like chickens!)

OK. I admit it. Stage hypnotists and their "victims" are often funny, and they do perform a useful service: that of getting across the message that hypnosis is relatively harmless. Unfortunately they also get across the idea that hypnosis is good only for making people look foolish, and this scares a lot of people away from using it.

In a clinical environment it takes a few weeks to develop the rapport between a hypnotherapist and a patient to the point where a usefully deep trance can be achieved. I often wonder at how deeply these people on stage are hypnotized. Probably not very.

When you think about it, each and every one of the stage-hypnotist's subjects knows full well that they are going to be doing embarrassing things. All of the hypnosis shows that I've ever seen work like that, so I expect that even before these people have gone up onto the stage that they have already decided that they are going to allow themselves to be made to look foolish. It's not much of a step then for the hypnotist to lightly hypnotize them and convince them to do something which they had, in their own minds, agreed to do beforehand.

TRUST AND NEGOTIATION. As you work through this book with your partner, it is important that you talk to each other, and that you discuss and agree on what you are going to do and how you are going to explore. Both you and your partner need to feel safe and comfortable with the things that you try and at the speed with which you progress.

Trust is a key word as far as I am concerned. Trust takes a long time to build. It is what enables one person to give up control so that the other can take it. It is at the heart of deep intimacy, and one of the biggest risks you run with it is that of destroying it via carelessness or abuse. It is a precious gem and should be recognized as the treasure it is.

WHY USE HYPNOSIS? I don't want to suggest to you that you use hypnosis in all your sexual escapades; instead I would like you to think about it as something that you can add to your box of toys – in with the vibrators, lubricants, whips, chains, latex underwear, silk teddies, honey, paint-on-lick-off chocolate and so on – and which you can pull out from time to time to add variety and spice to your activities. I want you to think of it as a useful addition to your sexual armory.

There are a number of answers to the question: *why use hypnosis?* Some have to do directly with the characteristics of hypnosis that you can apply sexually, and some have to do simply with the *mystique* of hypnosis; for example, the plain simple novelty of it.

NO MORE DISTRACTIONS. I talked earlier about *focus*. A trance is sometimes described in scientific literature as a state of *focused concentration*. There have probably been times in your life when you have been concentrating so much on a problem, or a movie, or a sporting event that you have lost awareness of what else was going on around you. Friends or colleagues might have called your name and tried to attract your attention but you didn't even hear them. All your thoughts were on the problem, movie or game. Being in a hypnotic trance can be like that too.

When you are worried, or when your stomach is making rumbling noises, or when there are other things going on around you which are distracting you from the action, hypnosis can be used so that these distractions fade into the background or even disappear completely. All that you'll then be aware of is your body, your own sexual feelings and your partner. Hypnosis can focus your attention on you and your partner and away from everything else.

INHIBITING THE INHIBITIONS. It's a good thing to be inhibited about some things: like walking around naked in front of others, jumping from cliffs and shooting people, for example. In most cases these are good and healthy inhibitions[1]. On the other hand, you sometimes find that you can't talk to your partner due to shyness, embarrassment or fear of looking foolish. These are also inhibitions and here they can get in the way of communication and intimacy with your partner.

Hypnosis can help you overcome these. It can reduce or eliminate shyness and embarrassment and let you do many of the things that you might like to do but which you normally can't. It can be a bit like having a drink to loosen up, but without the blurriness, the hangover and the recovery time, and while still remaining focussed and "sharp."

FANTASIES. I'm sure you've seen stage-shows where the victims..., er, subjects cluck their way around the stage thinking that they're chickens, or imagine that they are some famous rock-star, or even that they're naked in public.

It might not be that these things are sexually exciting to you, but you can maybe use this characteristic of hypnotic trance to your advantage. Have you ever imagined yourself making love to some gorgeous photographic model, or making love in some exotic location (like on the moon)?

Well, if someone in a trance can imagine – can actually feel – that they are chickens, why can't *you* have the experience of making love to a model, or movie star? Why can't you make love on the moon? There's no reason. Hypnosis can help you create more realistic and sexually exciting fantasies than you have ever had before.

ROLE-PLAYING. As well as imagining, or fantasizing, that you are with some other partner or are in some other place, hypnotic fantasies can help you become someone else for the duration. You can be a pirate, a muscle-man, a damsel-in-distress, a superhero, a warrior prince or mad-scientist, and spring from one side of your bedroom to the other, pillaging, raping or rescuing as you go. You and your partners' imaginations are the limits here.

1. *Unless you are Miss January, a rock-climber or a soldier, respectively.*

SEXUAL RESPONSIVENESS. I expect that you would have heard of cases where hypnosis has been used to reduce or alleviate pain. Most commonly you hear about this in relation to dentistry and childbirth, but it is also not unknown for major abdominal surgery to be performed using hypnosis as the only anesthetic. There's one really, really great advantage to this: there are no drugs and no after-effects. Immediately after the surgery the patient's mind is completely back to normal.

Now, what has this to do with sex? I hear you ask. Well, if you can use hypnosis to decrease sensitivity – which is what anaesthesia is – then you can also use it to *increase* sensitivity. Under hypnosis the warm pink bits of your body, or your partner's body, can become more sensitive and responsive than usual. This is great for people who have problems with sensitivity either naturally or as a result of some accident.

I'm going to use that *focus* word again here, because hypnosis also helps your partner focus their attention on, and get the most out of the feelings that you give them as you touch, caress and explore them.

Sometimes *decreasing* your partner's sensitivity can be useful. The most obvious example is in cases of early ejaculation. By hypnotically reducing your partner's responsiveness their ejaculation will correspondingly be delayed. This can help them feel better about their performance and about how much they are pleasing you.

A final note on responsiveness: with a partner who responds well to hypnosis it can be fun to play around *turning them on or off* (ie. making them completely unresponsive, and then making them hyper-responsive) when you, say, snap your fingers.

EROTIC CONTROL. Something that is not often spelled out in the world of sexual adventure is that to many people the idea of either taking control or of giving up control is highly erotic. This shows up most obviously in bedroom games like role-playing – for example: teacher-student, boss-secretary and master-slave – but also can be hinted at by who goes on top, or by who initiates sex.

Hypnotizing, or allowing yourself to be hypnotized, involves an explicit handover of control. Sometimes just the thought of this, fol-

lowed by even just a light trance, is enough to get the juices flowing and can lead to orgasms *extraordinaire*.

Look at your own fantasies and at those of your partner for a moment. Look also at which of you would like to hypnotize and which would like to be hypnotized. Think about how important control is to you – either having it or having it taken away from you. Being aware of your own desires in this regard and then using that awareness can be extremely rewarding.

VARIETY. Last, but not least in my list of reasons why you might use hypnosis with sex is *variety*. The more techniques and styles you have in your ways of making love, the more tricks and secrets you know, the more variety you will be able to add to your bedroom (or elsewhere) adventures and the more easily you will be able to adapt what you do to the moods of your partner and yourself.

Even if you manage to discount all the other reasons in my list above, combining hypnosis with sex can be a lot of fun; and to my mind, fun and laughter are some of the greatest aphrodisiacs.

MISCONCEPTIONS ABOUT HYPNOSIS. In the past, and maybe even today to some extent, it was easy get the idea from movies and TV shows that by hypnotizing someone you could control them completely. Not so. As someone goes into a trance their responsiveness to suggestions and to commands increases, and their inhibitions decrease. Their morals don't change though, and they are still quite capable of refusing. This basically means that they won't do *everything* that they're told and that you're very unlikely to get them to go to the local supermarket and either do a striptease or commit a robbery. Their minds are relaxed and some of the barriers are down, but that's all.[2]

Sometimes you see someone in a stage show being told to forget what happened during the trance. Once something has happened to them they can't really forget it. What happens is that they just can't remember whatever-it-was. This is entirely different from forgetting.

2. *This paragraph is accompanied by the sounds of thousands of horny guys looking for instant sex slaves slamming their copies of this book shut in disgust and then hurling it into the trash.*

Telling your partner not to remember something from a trance is a good way to surprise them with a post-hypnotic suggestion[3] and can be fun. However, even though they might not be able to remember it then, it's still in their mind and they can, and maybe will, remember sooner or later.

Some people worry about not being able to wake up from a trance. This is unfounded. Normal and healthy people in a trance, if left alone, will eventually end up awake of their own accord. They'll either drift into a normal sleep first, or will wake up directly. It might take a couple of hours, but they won't be stuck in a trance.

The fear of being left as a chicken, or similar, is not uncommon either and is also unfounded. The scenario for this is, of course, that your partner has a chicken fetish, or has had a bit of fun and has told you to act like a chicken and then hasn't cancelled the command properly before waking you up.

One of the great things about the human mind is that it is very resilient[4], it generally bounces back into shape very easily and quickly. So, while you might be able to hypnotize someone and push their minds into a sort of chicken-ey shape for a while, it won't stay that way[5]. Waking them up like that might leave them a bit confused for a few minutes, if that, but then reality will kick in and the chicken will be kicked out.

3. *This is a command given to someone while they're in a trance, which they actually follow sometime after they've been woken up from the trance. Usually the hypnotist gives the command in such a way that it is triggered by a key phrase or action. I will be talking about this more in detail in later chapters.*

4. *This very same resilience is one of the reasons that hypnosis and hypnotherapy didn't turn out to be the magic bullet in the area of psychotherapy that many researchers were hoping for. While you can achieve some truly amazing things with hypnosis, the effects often don't last long outside of the trance. It turns out that hypnosis is often best for exploring and finding out why someone has the problems that they do. Then non-hypnotic therapy techniques are used to treat them.*

5. *I think that this has to do with the instinct for survival. Your chances of coping with the world and of having a satisfying and happy life are probably not very good if you go around thinking that you are a chicken. You also might end up meeting someone who thinks that they are a fox and then you really are in deep, er, brown, smelly stuff.*

It boils down to this: the stranger it is, the faster it will usually wear off. This is one reason why the hypnotist in hypnosis shows keeps things moving very quickly: you can't count on subjects staying "programmed" for very long.

Finally, it doesn't require a "weak" mind to be hypnotized. Most of the scientific literature – and my own experience – says that the best and most responsive people to hypnosis are the intelligent ones. I believe that this is because they better understand themselves and are better able to control their own minds.

When you get down to it, there is no special power involved, and just waving your arms and talking to someone isn't going to put them under you control no matter how hard you try. When you hypnotize someone it's really more that you guide them along the path into a trance. They are the ones who go there, they are the ones that relax and give up that control. Even though they might just be sitting or lying there at the start, their minds play a very active part, and the brighter and more determined they are then the better the results.

WHO THIS BOOK IS FOR. When I imagine people reading this book, I see them as couples (married or unmarried, it doesn't matter) who are happy with each other, who like to explore and play, and who look forward to doing new and exciting things together. I see them maybe sitting in bed, reading the book, pointing to different paragraphs and exercises and exclaiming from time to time, "Hey! Let's try this."

To get the most out of the dollars you spent on this book, you'll need to be prepared to work, to talk to your partner about fantasies and fears, and to negotiate and plan the exercises together. You can expect to feel a deeper closeness with your partner as you talk about and learn their fantasies and desires, and as you discover new or stronger feelings.

People who do not currently have a partner can also, of course, read this book. I hope that they will find many of the things that I write about to be interesting and even useful, but they will best be able to use most of what is here when they have a regular partner.

Finally, this book is for *both* partners in the relationship. Even though much of the text, particularly in the later chapters, is directed

at the person doing the hypnotizing, the book as a whole isn't just for him. Both of you should have an understanding of what is going on and both need to contribute to the ideas and the direction that you take. This is, put simply, a team project.

WHO THIS BOOK IS *NOT* FOR. If either you are your partner are undergoing psychiatric treatment or counselling then you should leave this book alone. Exploring new feelings and intimacy while seeing a therapist (unless they know that you're doing it) can seriously disrupt treatment.

If you're taking anti-depressants you should leave this book alone. If you are going through any significant traumas in your life – such as loss or change of job, loss of a long-term partner, or any other form of crisis – you should also leave this book alone. Like I said in the paragraph before this, new feelings and intimacy can be difficult to handle and even downright disruptive at such times.

If your relationship with your partner is going through difficult times and you think that something like hypnosis might spice it up or fix it in any way, well, think again. It won't. If there are fundamental problems with your relationship then they need to be fixed first.

WHAT YOU NEED. Hypnotizing someone and then waking them up is quite easy... but some work is required. You'll need to think. You'll need to have patience. I don't assume that you already have experience, so I'll be explaining everything right from the beginning. Everyone reacts differently to hypnosis, so it also (unfortunately) isn't the case that you follow a fixed list of instructions and, at the end, *hey presto!*, your partner is in a trance. You'll need to watch your partner, see how they react, and then maybe turn back to this book to see what the reactions mean. You'll also need to have confidence, the ability to relax and the ability to concentrate. Everyone can do these things to some extent and the practice that you'll get in this book will help you get better at them

The same word *patience* keeps coming into my mind as I write, and I'm going to talk about it again here. The first few times you

hypnotize someone it might take up to fifteen or twenty minutes for them to go into a trance, and at the beginning it might seem that absolutely nothing is happening. You really do need to be patient, to work at it, to observe, and not to give up.

Hypnotizing someone basically means that you talk to them and give them certain instructions. Minimal equipment is required. Something for your partner to focus on is often used, and I, personally, often simply use the tip of my finger when hypnotizing someone. Do you have a finger? Yes? Then I'd say that you have everything needed. If you don't like using your fingertip, or if yours is particularly ugly, you can use the end of a pen, a candle-flame, a spot on the wall, or practically anything.

GUARANTEE OF SUCCESS? The scientific literature regarding hypnosis indicates that about 10% of the population is deeply hypnotizable (I'll explain levels of trance later), 10% of the population is not hypnotizable at all, and that the remaining 80% is hypnotizable somewhere in between. Most of the research has been on university students who have to volunteer for a certain number of experiments to pass their psychology degrees, so the results probably aren't representative of actually everybody.

My own experience indicates that having an enthusiastic partner virtually guarantees that you'll have success. By *success* I mean some level of trance within the first two or three attempts. One of the main things that I find which gets in the way of a good result is fear in my partner. Sometimes this is fear of losing control, and sometimes this is fear of the unknown (ie. the new experience).

Some of the exercises which I give later in the book will work quite well with only a light trance, and some of the exercises require a deeper trance. How deeply you or your partner can be hypnotized depends on many things. One of these, as I mentioned at the beginning of this chapter, is experience and you'll find is that as you more often hypnotize someone, or are hypnotized yourself, the depth of trance increases as both hypnotist and subject learn about each other and about themselves (e.g., how they can best relax).

How to Use this Book. The book is organized into three parts. The first part is this chapter: the Introduction. Following this introduction are the chapters which discuss and show aspects of the hypnosis process, including: different ways to hypnotize your partner, how to deepen the trance, how to wake up your partner, tips and tricks, different techniques and effects that you can try, plus some simple, non-sexual exercises to help you build your expertise at "plain" hypnosis. Finally, there are the chapters which discuss and show how to use hypnosis with sex.

Please read this introduction thoroughly, as well as the following chapters on how to hypnotize your partner and especially how to wake them up again. The final chapters – the ones containing the sexy stuff – are ordered according to skills required, beginners to advanced. I would strongly suggest that you work through this book slowly – maybe trying a different exercise every two or three evenings – taking as much time as you need to master the skills and techniques that I present.

What Is a Session? I use the term session regularly. What I mean by it is the period of time, or the series of things that you do, which are all related to some activity that you planned. For example, you might plan to talk to your partner, then hypnotize them, stroke and caress them until they come, then make love to them while they are still in the trance, finally wake them up, have a little chat about it and then go to bed. Everything from when you talked to them initially through the little chat at the end would be the session.

The Scripts. I expect that initially you'll find the scripts that I provide to be the most useful part of this book. I have tried to provide at least one for each of the techniques and effects that I describe. Even though you can read all the explanations and understand how it all works, it can be very difficult to remember the right words and the right order the first few times when you're on the spot – a little nervous – with your partner ready and willing in front of you. The scripts contain the words and actions that I might use with a partner and you can simply follow them, even read them out loud to your partner, until you start to get a feel for them and develop your own style.

WHAT *NOT* TO TRY. There is a lot of mythos surrounding the idea of hypnosis. These days it has been well-researched and its limits are widely accepted and understood. It might be tempting, if you find that your partner responds well to being hypnotized, to try and rid them of bad habits or to subtly change them to maybe align their sexual interests more with yours. This is a bad idea.

It is a bad idea because long-term changes in behavior or personality via hypnosis are in the realm of hypnotherapy – which I will get onto shortly – and require years of psychological training to achieve. What I discuss and show you in this book are neat and tidy scenes and experiences that mostly end when the session with your partner ends. I do not, and would not, attempt to have any of the material in this book lead to anything more than a better understanding of your partner and deeper intimacy. I very strongly suggest that you limit yourself the same.

HYPNOTHERAPY AND YOU. The goal of hypnotherapy is to use hypnosis and hypnotic techniques to cause a long-term beneficial change in a person. There are many aspects to an individual's personality. Any change in one part is going to cause changes in other parts. A therapist needs to learn and understand the individual's personality, and then needs to carefully plan how to achieve the desired long-term changes while still keeping him "well-balanced."

Even for something as simple as trying to help someone stop smoking, to get the best result – i.e., no smoking and no remission – it is often necessary to talk to the person, find out their history, work out why they started smoking, why they still smoke, what negative effects not smoking might have, and then plan the treatment accordingly.

The old trick of hypnotizing someone and telling them that every cigarette they smoke will taste like burnt rubber doesn't often work and, in any case, has bad side-effects of its own – for example, stress and nervousness.

What I'm saying is that hypnotherapy requires training. It requires years of study plus years of experience, often supervised. If you don't have this training, don't try it.

Hypnosis Courses and Further Study. The place to start if you want to pursue hypnotherapy as either a career or just out of interest is your state or national hypnotherapists association. You can find them under "hypnotherapy" or "hypnotherapists" in your telephone directory.

In larger cities you will probably find schools which offer training. In the U.S., they often show up in the classifieds under "Schools: Business and Vocational." Check also "training" in your telephone book. There are lots of shady, fly-by-night schools of all sorts out there, so before attending any school, check them out at the nearest hypnotherapists' association.

Books on hypnosis seem to come in waves. Check out larger book stores. Sometimes you find hypnosis books under "Self-motivation," "Self-help," "Therapy," "New Age" or "Occult." Ask someone who works in the store. A related subject which you might want to watch out for is Neuro-Linguistic Programming (NLP). It's a new approach, and there's not much in the way of reliable studies which show how well it works, but it is definitely worth a look.

Terminology and Four-Letter Words. Four-letter words and sex go together. In the heat of passion four-letter words seem to fly like shrapnel from an exploding grenade[6], so trying to sanitize the scripts that I present later and make them all Queen's English would leave many of them far less exciting and/or inspiring than I'd like. This is my excuse for having four-letter words scattered around the place. By nature I tend not to use them very much and this is reflected in the scripts. If you like to be more juicy in the way you talk in your bedroom scenes, please feel free to add the color of your choice.

Why I Wrote This Book. Let's see... The obvious reasons are, of course: to make money, to become world-famous, to have zillions of beautiful women throw themselves at my feet begging me to have sex with them, and to retire early (and pleasantly exhausted).

A more morally acceptable reason is that I have been interested in hypnosis since my teens – then studying and qualifying as a

6. *This metaphor copyright 2001, Peter Masters.*

hypnotherapist in my early twenties – and I have very rarely found any literature that tries to tie hypnosis to anything other than relaxation and giving up bad habits. My experience with hypnosis in my own sexual relationships has been universally good, and I am sure that there are lots of other people who either dabble already or who would like to.

This book collects all that you need to know to start. It isn't intended as the definitive work in the genre, but it does aim to cover the basics: how to hypnotize someone, what to do when you have hypnotized them and how to tidy up loose ends. It is specifically oriented towards sex, so you also won't have to pick up some other book that just talks about hypnosis and then try and guess what you can do with it in the bedroom.

I am sure that there will be adventurous individuals who will begin with this book and then go far beyond what I talk about.

How to Hypnotize Your Partner

A BIT MORE ABOUT HYPNOSIS. Researchers have for a very long time tried to understand hypnosis. Originally, of course, it was thought of as sleep[1], then it was thought of as an "altered state of consciousness." Now, using instruments which can monitor brain activity, they have found that there is negligible difference between someone in a trance and someone who is not. (When you consider that there is something called a *waking trance* – in which someone in a deep trance acts like they are wide awake – this is probably not surprising.) In other words, someone in a trance is just as awake as you or me right now.

And the researchers? They still cannot explain hypnosis, but they can describe it and its limitations. And that is what is important to us here.

So WHAT IS IT? People's experience of hypnosis often varies widely depending on expectation and what actually happens to them during the trance, but some things do seem to be common. Most people who are hypnotized without having any other instructions given to them find that they are so focused on their hypnotist's voice that their awareness of what is going on around them is either reduced or completely

1. *Which is where the name came from: hypnos, Greek god of sleep.*

gone. This can include reduced awareness of noises and sounds, including conversations going on around them, and reduced awareness of their own body (including arms and legs), which sometimes gives them the feeling that they are floating. Sometimes this focusing is so intense that they can have trouble thinking.

Extreme, and I mean *really* extreme, physical relaxation is often common, even to the point of the subject seeming like a rag doll. This relaxation is probably a result of the way most people are hypnotized, with the word *relax* being used over and over again.

I want to repeat something here because it's important that you understand: someone in a trance is not unconscious and they are not asleep. Lots of the terminology that we use might hint at sleep – like saying that we "wake someone up from a trance" – but it isn't so.

When someone is in a trance their mind is still working, they are still thinking and they are generally aware, to some extent, of what is going on around them. Their personality is still intact and they are still exactly who they were before they were hypnotized.

When someone is in a trance they are typically more responsive to the commands and suggestions which the person who hypnotized them might give them. This means that they'll more readily accept what you say to them. For example, because their eyes are usually closed most of the time that they're in a trance, and because their attention is focused *away* from what's going on around them, it's easier for them to imagine that they are somewhere else. This means that fantasies in a trance are typically more vivid than waking fantasies.

The phrase *depth of trance* is used to indicate how much someone is hypnotized. The deeper the trance the more responsive or more involved they are; the lighter the trance the less responsive they are. When you hypnotize someone they go from being awake into a light trance, then they can progress from there into a medium trance and finally into a deep trance.

For some of the exercises in this book, particularly the more advanced ones, the deeper the trance the better they'll work. This doesn't mean that you need to or should always try for the deepest possible trance. For many of the exercises in this book a light trance is enough,

and it can often be more suitable than a deep trance because it's easier and simpler to achieve.

Whether someone can be hypnotized at all, and how deeply they can be hypnotized, depends on many factors as I mentioned in the introduction. In my experience fear of the unknown and fear of being made to look foolish seem to be two of the main factors. Trust is another one, ability to relax and let go, and practice – or experience – are others. Even when you have a lot of experience hypnotizing lots of people you can never really be sure how deeply you will be able to hypnotize, if at all, someone new. The only way to really know is to try it.

POST-HYPNOTIC SUGGESTION. One of the really fascinating things that you can do with hypnosis is called *post-hypnotic suggestion* (PHS). I'll be talking more about this in a later chapter, but there are a few things that I'd like to include here. Post-hypnotic suggestion is a command or suggestion which you give your partner while they are hypnotized which they are supposed to follow *after* the trance. the PHS can be phrased so that it "triggers" at a particular time or following a particular action, like the classic snapping of your fingers.

As I mentioned in the introduction, while in a trance, your partner's moral values are still in place. The same applies to PHS – you can't use it to make your partner commit crimes or do anything that might offend their own sensibilities.

You might try, for example, telling your partner (while they are hypnotized), "Tomorrow at noon you will go down to the local shopping mall, take off all your clothes and then dance around naked for five minutes." Unless your partner is a professional striptease dancer this is not going to work – or, at least, not the way you'd expect.

Looking at this more closely, let's suppose that your partner is really responsive to hypnosis and that you'd managed to hypnotize them very deeply before giving them that particular PHS. What is likely to happen is that the next day, at noon, they will feel something between a mild desire to a strong compulsion to go down to the shopping mall. Assuming that there's no reason for them not to, like work obligations, they'll go.

The command you gave them also told them to take off all their clothes. They aren't going to do that in a shopping mall, are they? No? Well, the answer is: Maybe. You see, the PHS is pushing them to take off their clothes and their morals are saying, "No!" in a loud voice to undressing in public. Without even consciously being aware of it your partner's devious mind will look for a way out, a way where both the command and the morals can be satisfied. Looking at the original command, it *didn't* say where in the shopping mall this undressing and dancing was to take place. In fact, if it gets this far, your partner is likely to end up in either a changing room in a shop or a public toilet.

Even if you did give them the post-hypnotic suggestion in such a way that it was spelled out exactly where they were supposed to do this public strip and dance, it is more likely that their morals would step in and break the command before they went too far.

Now, a warning: if you try to pull a stunt like this, while it might seem like a fun idea, it can have very serious negative consequences for your relationship with your partner. The issue under threat is *trust*. What you are doing if you try something like the above without your partner's permission is abusing their trust. If someone tried this with me I would happily kick the person who tried it right out of my life.

What happens when a post-hypnotic suggestion is triggered varies from person to person and can be different for different suggestions. Your partner might feel anything between a mild desire, as I mentioned above, to a strong compulsion – something like the "pull" of a strong habit – to do this particular thing. They might not know why, or they might remember that you told them to do it while they were hypnotized.

It might also be that they will suddenly come up with a more-or-less plausible reason for doing the thing. For example, you might tell them that they'll go to the corner store at a certain time the next day and then, at that time, they "realize" that they need to go and buy some milk.

The way your partner behaves when carrying out the suggestion can vary too. Some people will go back into a trance while carrying it out (you can usually see this in their eyes) and they may not even remember doing whatever it was afterwards. Or if the command is

really simple they might do it without even thinking about it. For example, I once hypnotized a friend in my home and told her that five minutes after I woke her that she would take a clown doll that I kept in the corner of the room and put it to bed. I woke her up and then, almost exactly five minutes later while we were talking about something else, she got up, took the clown and tucked it into my bed, all the while carrying on the conversation. It wasn't until I asked her why she had done it that she realized what she had done and become somewhat confused – until I explained that it had been a post-hypnotic suggestion.

Post-hypnotic suggestions can be fun – think about stage shows which you might have seen, for example – but given their unpredictability, particularly with a new partner, you should only use those that trigger while you are with your partner. In stage shows, too, the hypnotist makes sure that the *fun* stops once the people who have been hypnotized have left the theater.

I will give examples and explain more in a later chapter.

AMNESIA. You can give your partner a post-hypnotic suggestion to not remember something[2]. These sometimes work, and sometimes they might work for a long time. Generally I find that this sort of PHS is not to be counted on. It might not work in the first place, or else the memory might come back after some unguessable period of time between seconds to months, or else it might come back after a sudden surprise – which has nothing to do with the PHS – or after triggering another PHS.

Basically this means that your mileage can vary with this one. Try it by all means, but don't count on it.

HOW YOU DO IT... IN BRIEF. Here are the steps that you follow when hypnotizing someone. I will expand on these shortly and explain each one in detail, but it's enough for the moment that you can see that there are eight individual steps or phases:

2. *When someone doesn't recall something that happened during a trance it is called post-hypnotic amnesia. This can sometimes happen spontaneously.*

1. Sit your partner down, relax them and set the scene.

2. Get them to focus their attention on something: an object, an image or a sound.

3. Talk to them in the future tense telling them how they *will* feel (e.g., relaxed, drowsy, heavy, calm, content, etc.).

4. As they start to respond you switch to the present tense to reinforce how they *do* feel.

5. They sink into a light trance where you do some simple testing and then guide them down to the depth of trance that you feel is required.

6. You do the exercise or activities planned with them.

7. You wake them up.

8. You debrief them.

With someone who has never been hypnotized before it might take fifteen to twenty minutes to go from step 1 to 5. With someone who has had plenty of experience and who you have hypnotized before, it might take less than a minute. The series of steps which you follow to hypnotize someone is called the *induction*.

The last two steps are not necessarily the most important ones – all the steps are important to having a successful session with your partner – but are probably the ones which I would recommend that you be best at.

Waking up your partner is obviously something that you want to be able to do. Many people are worried or afraid of not waking up from a trance, and it pays to reassure them by getting it right every time. While you cannot intentionally or accidentally leave them in a trance forever, it is possible to leave them with a headache by rushing through the wake-up, or leave them groggy by not being thorough.

Also, do not underestimate the importance of the debriefing! Although things will most likely work without it, your long-term progress will go *much* faster if you take some time to discuss each session with your partner, either right afterwards or maybe the next morning. You can learn an enormous amount in the debriefing about your "performance" and the feelings and responses of your partner. It's worth its weight in gold.

In the rest of this chapter I will explain this all in more detail, including the words you can use and why you use them. Then, later on in the exercise chapters you'll see how this all comes together.

WHAT TO EXPECT. When you hypnotize someone the first few times it can be very frustrating. Frustrating because you start the induction and nothing seems to happen! Your partner is sitting there in a nice, comfy chair, with their eyes focussed on, say, a candle-flame. You've relaxed them and you are now doing step 3, the future tense step. You are saying all the things that the book says to say and your partner is still just sitting there, blinking occasionally, but still just sitting.

You keep going, beginning to doubt yourself, your voice, your partner, the book, everything. You wonder how long you need to keep going. You wonder how disappointed your partner is going to be because it didn't work. It seems hopeless and you wonder how long you should keep going before you give up.

And then your partner's eyes flutter; just a bit, but they flutter. You start watching more closely as you say the words that you've been rehearsing so much. Then their eyes flutter again and you notice that their head has begun to sag down just a teeny-weeny bit. These are the signs that you've been waiting for, the signs that the book said to watch for, and all of a sudden your heart is filled with joy, the sky is bluer, the sun is brighter and your confidence returns. You realize with relief that it's time to move on to step 4, the present tense step.

When your partner is in a trance and you try some of the exercises, you might find that they are very sluggish or slow to react. Or they might respond instantly to commands. It's difficult to tell beforehand, and it's impossible for me to prepare you for all possibilities. What I will do in the exercises later is start slowly with very simple activities (like standing up and sitting down) and explain the different things that can happen, and then move on to more complicated exercises.

I very strongly advise you to work through each and every one of the non-sexual exercises. They will slowly introduce you to the way your partner reacts while in a trance. By following the these exercises you can expect not to have any big surprises later... maybe a few small ones, but no big ones.

One thing that I can tell you is that someone in a trance can be very literal-minded. You will probably need to get into the habit of being very clear about what you actually want them to do. I'll give you two examples of how things can go not quite right: you might want your partner – whom you have just finished hypnotizing and who is still sitting in the nice, comfy chair – to get up and go over to the bed. Sounds simple? OK. So you try it and you find that they actually do get up but head the wrong way, or they trip over things, or they run into the wall. What went wrong? Almost certainly you didn't tell them to open their eyes so that they could see where they were going. Simple, but not obvious.

The second example has happened to me, but you'll see that there can be endless variations to it: My partner hypnotized me and, at one stage, had me standing in the middle of the room. She wanted me to sit down in a nearby chair, but she told me simply to "sit down." I sat down right where I was, ending up cross-legged on the floor: not what she had wanted at all.

The moral is: it pays to be explicit.

You are likely to find that not all of the exercises will work. This is often simply due to your partner just not being capable of doing them. For example, if your partner has poor visualization skills normally when they are awake, telling them to imagine that they are on a beach while they are hypnotized may not be a big success. On the other hand, if your partner is an artist and you try the same thing you may find that they are capable of creating the whole scene in their minds, complete with breeze, sunshine, sounds of waves, feeling of sand underfoot and so on.

Or you might have in mind a semi-perpetual erection for your partner, maybe lasting for hours, and subsequently be disappointed when it fades away after a while. Hypnosis doesn't make your partner super-human, so while their mind may be focused and they may be able to maintain an erection longer than usual, it won't last forever. Male bodies just don't work like that.

Another thing to keep in mind is that people are basically weird and react in weird ways. Here's an example: I tried to hypnotize a new-ish lady friend once. I sat her down, relaxed her and started the

induction. After a minute or so she started to respond positively, i.e., there was the occasional twitch and her head clearly started to sag downwards. All very good, you might say. But then she suddenly started to laugh – as though she had just heard a really good joke – and snapped right out of wherever she was! Very disconcerting, and she didn't know what was so funny or why she was laughing!

The psychologists amongst you might recognise what had happened: I believe that she had agreed to be hypnotized not fully expecting that it would work. Then, when it had, her fear of losing control (which might have also involved lack of trust in me seeing that we had not known each other very long) had reared its head in her subconscious and it simply did something to stop or interrupt what was happening to her. It wasn't conscious on her part and I think that consciously she really did want to be hypnotized.

And on the subject of laughter, someone in a trance can say and do very funny things which to them are completely serious. It's OK to laugh as long as by doing so you don't put down their fantasies or ideas.

Another partner of mine was an excellent subject. She could go into a very deep trance very easily, and while she was there she was capable of imagining and involving herself in almost any scene as though it were real. One day I decided to try a session where she imagined we were on the moon, i.e., practically weightless. So I hypnotized her and suggested that, and then, to check out how she was going, I asked her to describe how she felt and what was there.

Well! She came out with the most amazingly funny description including inflating heads and people like George, her chauffeur,[3] who drove her around up there. I couldn't help laughing and ended up practically in stitches as – my original session plan abandoned – I let her continue to wander around on the moon and describe her adventures.

VERY IMPORTANT. Once you have started a session with your partner *always* end it by doing a wakeup (see below). Even if you have

3. *In real life she had no chauffeur and drove around in a rusted-out second-hand Toyota.*

tried to hypnotize your partner and it hasn't seemed to work, do a wakeup anyway. Even if none of the tests that you've tried have worked, do a wakeup anyway. Even if your partner has gotten up and walked away, do a wakeup: say the words anyway. Your partner might have gone partially into a trance and neither of you has realised. You might feel like an idiot waking up someone who seems obviously not in a trance, but do it *anyway*.

THE VOICE. Many hypnotherapists develop what is often called *the Voice*. This is basically a set of tone and verbal mannerisms which they use when hypnotizing and working with their clients. *The Voice* is strong, firm, clear and authoritative. It's often slightly deeper in pitch than the their normal speaking voice. *The Voice* projects confidence and is compelling. Ideally, when hypnotizing your partner you should develop your own *Voice*.

Start by learning the scripts that you are going to use so that you don't have to refer to notes. Understand the meaning of all the words. Then, when you are talking to and hypnotizing your partner, speak slowly and enunciate clearly. Put a little force behind the words. Make the suggestions sound like orders. Don't be overbearing or too aggressive, though. Your partner wants you to be in control, otherwise they wouldn't be letting you hypnotize them. Take that control and assert it right from the start.

An advantage of having a separate *Voice* which you use only when hypnotizing your partner is that it reduces the chance of a partner who is very good at being hypnotized going into a trance unexpectedly. Anyone who is good at being hypnotized will – when hypnotized the same way, in the same place and by the same person regularly – develop the *habit* of going into a trance to some extent under those circumstances. It can be enough to say just a few of the same words that you use when hypnotizing them in the same tone to put them into a light trance even when they aren't expecting it.

Developing a *Voice* which you use only when hypnotizing your partner helps prevent this habit from forming. For you at home this wouldn't be much of a problem – either you or your partner notice

that they have started to go into a trance and you simply wake them up. Imagine the difficulty though, for a therapist who regularly hypnotizes their clients and then finds them in a trance each time they ask even simple things like, "How's the weather outside?" or "How have you been since last I saw you?" Therapists talk to their clients using their normal voice, and hypnotize them using a different voice so that there is no confusion and so that their clients don't wander off into a trance before the therapist is ready.

THE WORDS. In conjunction with the voice, the words which you use are very important because, along with helping your partner to relax and go into a trance, they can also build up expectation for what your dirty little mind... er, imagination has conjured up for later. The first couple of times I hypnotize someone I try and make it as plain, simple and direct as possible—you'll see that in the rest of this chapter. Once I am comfortable with hypnotizing them I'll start adding in the spice.

Step 1 - Relaxation and expectation. This step is where you relax your partner and set the scene (otherwise known as building up their expectations) prior to the main part of the induction. How your partner is feeling about this whole thing during this first step is going to have a very big influence on the whole session. It is important that they are enthusiastic, comfortable and reassured about your competency.

Sure, the first time you hypnotize your partner they probably also know that it is your first time, but if you have studied well, discussed it all with your partner and made your preparations properly, they will have confidence in you and your authority.

If your partner has little or no experience at being hypnotized I very strongly suggest that the first few times be done well away from the bedroom and with both of you fully clothed. The reason is that in the next step of the induction you will ask your partner to focus all their attention on something like a candle-flame or spot on the wall, and they might find this very hard to do if bits of your naked body are dangling in front of them. So until they have some experience, keep unnecessary distractions to a minimum.

One thing that is not immediately obvious is that you need to make sure that your partner has been to the toilet before you start. Stirrings in the bladder or bowels can be very distracting when they are trying to relax and go into a trance.

Start by sitting them in a quiet room in a nice and comfortable chair, possibly with a straight back and with arm rests. It needs to be as comfortable as possible because you don't want their concentration distracted by cramps, lumpy cushions or back pains. Have them loosen any tight clothing or shoes[4]. Both feet should be flat on the ground and either their arms should be lying on the armrests or else they should have their hands resting palms down on their thighs. Under no circumstances should they have their legs crossed[5]. Also try and make sure that no matter how much they relax that they will not fall out of the chair[6]. Make sure that there are no bright lights or moving objects which might distract them.

Once they are comfortable talk to them briefly about the technique you will use to hypnotize them (which we'll got into later) and what you will be doing once they're hypnotized. You can then further relax them possibly like this:

I want you to close your eyes. Now. I want you to take three deep breaths as I count. Breathe in deeply each time and then, as you breathe out, I want you to consciously relax yourself. Maybe you can imagine that any nervousness or tension is being breathed out with the bad air.

OK. Now, ONE. Breathe in... Now breathe out and relax.

TWO. Breathe in again, and shake your hands and wiggle your

4. *This is because when you hypnotize your partner they will relax, and their metabolism, including their heart, will likely slow down. This is a consequence of the relaxation and not the hypnosis itself, but with the slower heart rate, constrictive clothing might cause circulation problems.*

5. *This is again to make sure that there are no circulation problems.*

6. *Because it's very easy for a rag doll – which your partner might become as all their muscles relax – to either slide out or topple out of the chair. While it's unlikely to hurt them or cause problems, it is still disconcerting to be talking to a pile of arms and legs on the floor.*

feet and settle them down comfortably... Now breathe out and relax a little more.

THREE. Breathe in, relax and... breathe out.

Breathe normally now.

During this step you need to be calm, confident and, very importantly, in control at all times. This doesn't mean that you have to shout or be aggressive. Just know what you are doing and set the pace yourself. It can be helpful, if you are nervous, to take three deep breaths with your partner as well.

Step 2 - Focus. One of the universal constants of hypnotizing someone is starting with their attention focused on something. In movies it might be a pocket watch swinging on a chain, a spinning spiral or it might be staring into the villain's eyes[7]. It doesn't have to be that your partner has their *eyes* focused, it can also be their hearing or their imagination. This means that there are three possibilities:

1. Looking at something. For example: a candle flame, the tip of your finger, the end of a pen, or a spot on the wall.

2. Listening to a sound. For example: the ticking of a metronome. This is a technique that I particularly like.

3. Imagining something. For example: being in a fog which is slowly changing colour, or watching the sun slowly set.

In ordinary life we say that someone's mind might be predominantly visual, or practical, or spatial, or whatever. Having these different ways for them to focus their attention means that we can pick one that best suits how their mind works.

When your partner is focusing their eyes on something, obviously they start with their eyes open. When they are focusing on a sound or image, their eyes are closed. Some of the more technical literature on hypnosis talks about *closed-eye* or *open-eye inductions*. These are sim-

7. *Which, in reality (the title of this book notwithstanding), is a most unpleasant way to hypnotise someone. As I mentioned earlier, it might take 15 or 20 minutes to hypnotise someone the first time. If you have them "staring into your eyes" for all that time, it also means that you have to stare back for all that time and cannot let your eyes wander. This is so tedious.*

ply techniques for hypnotizing someone, like those which I will be describing, which start with the eyes closed or open, respectively.

The point where your partner will be focusing their eyes should be small, just above the level of their eyes, and should be easy to stare at. I listed some examples above, but any more-or-less stationary point is good. Until you have some experience I recommend that you *don't* use body parts like eyes or fingers because it can be hell keeping them still in front of your partner for more than a couple of minutes. I much prefer a spot or a small flame because then I can sit or stand around to one side, out of sight of my partner, and fidget or twiddle my thumbs as much as I like without distracting them.

The sound which I like to use best, as I mentioned above, is the ticking from one of those older-style clockwork metronomes with the upside-down swinging pendulum. They make a nice, woody tock sound and are not irritating like some of the modern electronic metronomes. I set mine to about sixty beats per minute.

Good images to use are simple and not exciting. Having your part-ner imagine a wild party or some other adventure isn't going to work very well. Imagining the sun slowly setting, or imagining being sur-rounded by a thick fog which is slowly changing colour will work much better. A good idea is to then associate in your partner's mind the setting of the sun or the changing colour with the sinking down into a trance.

What you might say to your partner to focus their eyes on a spot on the wall, for example, could be:

Now I want you to look at the spot on the wall. I want you to look only at the spot and not at anything else. Try to ignore everything else, as well as any sounds or noises that you might hear other than my voice. Focus as completely as you can on the spot and don't let your eyes wander.

Using a metronome is slightly different. You only need the ticking sound when you are actually hypnotizing your partner. Having the metronome running at other times, like beforehand when you are re-laxing them and talking about what you are going to do, or leaving it

running once they are in a trance, can be distracting or confusing to both you and them[8].

Words which you might say when using a metronome are:

Close your eyes now... Good. In a moment I am going to start the metronome. I want you to listen to the ticking of the metronome. I want you to focus all your attention on the ticking as completely as you can.

(Start the metronome.)

... Now concentrate on the ticking of the metronome.

I mentioned earlier about being explicit. There's a good example here where I said, "Close your eyes." Don't assume that your partner will know that they are supposed to close their eyes. Take control and tell them exactly what you want them to do.

Let us continue now with getting your partner to focus on an image or scene in their mind. The best sort of scene is simple and is one that slowly changes. It also has a definite end, like the setting sun example that I mentioned, i.e., at the end the sun sets. The idea is that your partner focuses on the scene and as it changes they go into a trance. The end of the scene is a good signal to *them* that they are in a trance[9].

8. *I had a partner once who was so used to me hypnotizing her using my trusty old wooden metronome that whenever I started it she would go straight into a trance. I didn't have to say anything at all! I could just start the metronome and, regardless of what she was doing and whether she was sitting or standing, as soon as she heard it she would start to relax, her eyes would close and within about 20 seconds she was in a trance. This was excellent for our sessions together, and it shows something about expectation. Because she was a good subject and our sessions went well, she grew used to going into a trance when she heard my metronome – she expected to go into a trance when she heard the ticking and, even when I didn't say the words, her expectation was so high that she went into a trance anyway. If you always do the same basic "scene" when hypnotizing your partner – like always sitting them in the same chair in the same room and always using the same focus, like the metronome or a spot on the wall – then they will get used to this. You'll find that each time they'll go more quickly into a trance. It becomes a habit.*

9. *Many people, surprisingly, cannot tell that they are in a trance. It can be reassuring to let them know, either by a subtle signal like the end of the imagined scene, or by actually telling them so.*

When you use an imagined scene you need to describe it so that the way the scene unfolds in your partner's imagination matches the words you are saying:

Close your eyes now... I want you to imagine that you are sitting on a deserted beach at the end of the day, and that you are looking over the water towards the large, orange sun as it begins to set. The sun isn't so bright that it hurts your eyes. As you watch, the sun is almost imperceptibly sinking down towards the horizon...

Step 3 - Future tense. This is the step where you start telling your partner what they will do (i.e., go into a trance), how they will feel (i.e., relaxed or drowsy), what will happen to their eyes (i.e., they will become tired and then close) and the sensations that they will have (i.e., heaviness in the head, arms and legs). Surprisingly, this is what hypnotizing someone is all about – telling them what's going to happen, using a few tricks to help these things happen... and then they happen. This doesn't sound very scientific and, in fact, what actually occurs inside someone's head that puts them into a trance is not well understood. The actual *procedure* for hypnotizing someone is well understood, though – and that is, of course, what I want to you to be able to do.

I mentioned tricks. What you try to do is use reality to reinforce what you are doing. If you get someone to stare at a spot on the wall, particularly if it is a little bit above eye level, their eyes *are* going to get tired anyway. If you've already said to them, as part of the induction, "... as you stare at the spot your eyes are going to become heavy and tired," then they are going to think, "Goddamn! This is really starting to work!" Exactly the same thing applies to arms and legs. Leaving them relaxed and in the one spot for any length of time is going to make them feel heavy, or a bit *wooden*. Include this prognostication[10] in your induction and you will seem like a master hypnotist[11] and your partner will talk themselves into a trance.

Let's look at a script that you might use during this part of the induction:

10. *Telling of the future, or seeing into the future.*

11. *Unless they have read this book too.*

I want you to keep concentrating on the spot on the wall. Soon you will feel your body start to relax more than it is now. Your eyes will become a little tired, they may start to water a bit and your eyelids will become heavy. Your arms and legs will relax and they too will become a little heavy.

My voice will help you to relax, and will help you to go into a pleasant, relaxed trance. My voice will act as a guide, and as you hear it any tension that you might feel, and any worries that you might have, will evaporate so that all you feel is deep relaxation.

Each time you breathe in and out your body will relax. It will be as though any tension or nervousness that you feel is breathed out with the bad air as you exhale. Your tummy muscles will relax. Your neck and shoulders will relax. Your thigh and calf muscles will relax, you will feel the tension draining out of them. You will also feel the muscles in your upper and lower arms relaxing, and the muscles in your wrists relaxing.

The muscles in your face will relax, the ones in your cheeks, your lips, around your eyes… all those muscles will relax.

Now, at the same time as your neck and shoulder muscles start to relax, your head will become a little heavy and it will soon start to sink down towards your chest. As your head sinks down you will also sink down into a trance. Your eyes will be heavy and tired and they will close. You will sink into a deep trance.

All this is said in the future tense. You describe everything that you expect to happen. Try not to leave long pauses anywhere; the idea is that you are in control and that your partner's mind is focused on your voice. Don't give them too much chance to be independent and to think about or analyze what's going on. Keep your words flowing, but don't rush them.

You keep this up until they start to respond, i.e., until you see clear signs that they are starting to relax the way you said. One of the really big benefits of hypnotizing someone who is sitting in a chair, as opposed to someone lying down, is that you can see the things start to

happen: like their head starts to droop, their shoulders sag, their eyes flutter or start to close. If you're very observant you might notice their facial muscles start to relax.

One of the clever bits in the above script is the way that breathing is tied into it. As your partner sits there breathing, the regular body movements caused by this will help the muscles in the chest and tummy relax *anyway* – which is even further reinforcement of the "fact" that they are relaxing and going into a trance.

Note also the way I associated the sagging of the head with the going into the trance. This raises an expectation, and when your partner's head *does* start to feel heavy and sink down they will *will* themselves into the trance with it[12].

Step 4 - Present tense. When I was first learning how to hypnotize – apart from remembering all the different words – the hardest part was recognizing when the person I was hypnotizing started responding and hence when it was time to switch from "you will..." to "you are"[13]

This is a difficulty that I still have with some people, and it's *the* reason why I always hypnotize someone the first time with them sitting in a chair in a well-lit, but not brightly-lit, room; it simply lets me see and get more clues about what is happening.

Things that you should watch for:

1. They start to blink, their eyelids flutter or their eyelids start to close.

2. Their head begins to sag or sink down towards their chest.

12. *Another way of hypnotizing your partner which uses this association of physical actions and going into a trance is the bucket technique. Explained simply, what you do is have your partner hold one arm straight out in front of them and ask them to imagine that they are holding an empty bucket. Then you tell them that the bucket is slowly being filled with water and it is becoming heavy. As it becomes heavier their arm will become tired and sink – which it will anyway even though they really aren't holding a bucket. You tell them that as their arm sinks down they will sink into a trance.*

13. *That is, for example, you stop saying things like, "Your head will feel heavy and start to fall forward," and start saying instead, "Your head is feeling heavy and is starting to fall forward." In other words, you start switching from using the future tense to using the present tense.*

3. Their breathing slows down and/or becomes shallower.

4. Their hands or feet twitch.

All of these are all good indicators and tell you that it's time to include some present-tense confirmation of what is happening in your script:

Your head is feeling heavy. It is starting to sink down towards your chest now as you relax and begin going into a trance. As you continue concentrating on the spot on the wall you can feel your body relaxing more and more. Your head will continue to sink down, your eyes will become heavier and you will go into a deep, relaxed and comfortable trance.

Your arms and legs are relaxing and become heavier, and as you breathe in and out that relaxation will become deeper. Your mind will relax and once you are in a trance you will respond completely and totally to what I say.

My voice is helping you to relax more and more now. It is guiding you, helping you to go down into a deep trance.

As your eyes become heavy and tired let them close. Don't fight it. Let the relaxation flow through your body and let yourself sink down into a deep, relaxing trance.

As the signs of relaxation become more obvious you include the present tense more and more in your script:

You are relaxing more and more, and are sinking down into a deep trance. Your body is relaxing. The muscles throughout your body are all relaxed and you are just sitting there listening to my voice.

Your mind is emptying so that all there is is the sound of my voice. Your eyes are closed, your breathing regular and the relaxation is getting deeper. You are sinking down into a deep trance and you will respond completely and totally to what I say to you.

Once your partner's head is down as far as it will go and their eyes are closed[14], you can probably safely assume that they are in at least a light trance. To be sure, continue for about a minute or so and then move into the final part of this step–something like this[15]:

You are in a trance now. Your body and mind are relaxed now and you will listen to, and respond to, everything that I say to you. I want you to keep going deeper into this trance until I wake you up later on.

As I said earlier, many people cannot tell they are in a trance and it's good to both reassure them and, by confirming the fact, prepare them for the next step.

Step 5 - Testing and deepening the trance. At this point you have your partner in a trance. Unless they're experienced, it's probably a light one the first couple of times. Now it is a good idea to combine some simple tests with some deepening techniques. The tests will give both you and your hypnotized partner some confidence and "feel" for where you are at. Don't be too concerned if the first couple of times the tests don't work.

In the scripts I am about to give you please note how I spell everything out to my partner – not just what I want them to do, but also the signals that tell them *when* I want them to do these things. This is important because your partner needs to feel that you are in control of *everything*.

As your partner successfully performs each test it confirms in their mind that they are in a trance. It's a very good idea then to pause for a minute or so before doing the next one. Spend this time relaxing them and helping them to go deeper into the trance. You'll see how I do this here.

14. *I have been assuming all the way along here that you have been getting your partner to focus on a spot on the wall. Only slight changes are necessary to use this same basic script with a metronome or with an imagined scene.*

15. *If you are using a metronome you should tell your partner that you are going to stop it by saying something like, "I am going to stop the metronome now," and then do so.*

EYES OPENING AND STARING. This is an excellent first test. All that you do in this one is get your partner to lift their head and then open their eyes. This is nice and simple and you can learn a lot by watching how they do it, and by looking at their eyes. Don't feel tempted to wave your hand in front of them[16] and don't stand where they can see you. Unless it's part of the test keep anything that might distract your partner, including you, out of sight or off to one side.

What you can expect in this test is that their eyes open, maybe just partially, and they will be somewhat glazed. If your partner opens their eyes and looks around as if they are awake then you can be reasonably sure that they are either in only a very light trance or not in a trance at all.

I am going to count to three in a moment. When I reach three I want you to lift your head up straight[17] and then open your eyes and stare straight ahead. I don't want you to wake up[18] when you do this. All I want you to do is lift your head up and stare straight ahead when I count to three. Shortly after that I will touch you on the shoulder. When I do that I want you to close your eyes, let your head sink back down again, and then I want you to go deeper into the trance.

Ok. One... two... three.

(Watch as they lift their head up. Don't stand in front of them and don't get up really close, but have a good look at their eyes. Then, once you have seen enough, touch them on the shoulder.)

Good. Now close your eyes and let your head sink back down onto your chest.

16. *All too many people seem to have picked this up from the movies. If your partner is not in a deep trance waving anything in front of them, particularly up close, is likely to frighten them.*

17. *The first few times I did this test I didn't tell my partner to lift their head up. This meant, with their head down on their chest and their face in shadow, that I had to bend down, sort of peer up at their face and then squint at them trying to see their eyes properly.*

18. *It's important that you say this because some people will equate opening their eyes to waking up. Make sure that they know that you don't want them awake now.*

Relax now and sink deeper into the trance[19]. As I talk to you, you will sink down, you will relax more and more, and become more open to the commands and suggestions which I give you.

Your mind and body are continuing to relax. Each time you breathe in and out you will sink down deeper into the trance.

FINGERS INTERLOCKING. This next test is a type of *challenge*. This means that you tell your partner that they cannot do some simple thing that they would be able to do if they were awake, then you challenge them to do it. The test succeeds when your partner either has more difficulty doing the thing than they would have if they were awake, or else cannot do whatever it is at all. In this particular test you get your partner to clasp their hands together with their fingers interlocked and then tell them that they cannot pull their hands apart. Then you get them to try.

What usually happens when you do this with someone is that the muscles in their fingers become tense and their fingers become jammed between each other. At the same time they start trying to pull their hands apart using their shoulder muscles. The best result is that they pull and pull but their hands stay locked together. A good result is when their hands seem locked together but the pull from the shoulders wins out and the hands come apart. The test fails if their fingers/hands just slip apart from each other.

I want you to listen closely to my voice now. In a moment I am going to count to three. When I reach three I want you to clasp your hands together on your lap with your fingers interlocked. That's all I want right now—just your fingers interlocked when I count to three.

One... two... three.

(At this point your partner should bring their hands together and interlock their fingers.)

Good. I am going to count to three again in a moment, and this time when I reach three I want you to try and pull your hands

19. *This is where you deepen the trance after the test.*

apart. When you do, you will find it difficult to get them apart; it will seem like your fingers are locked together. When you try to pull your hands apart your fingers will seem tightly locked together and the harder you try to pull your hands apart the more tightly locked together they will become.

OK. One... two... three. Try to pull your hands apart now.

(Watch for a moment to see what happens.)

Ok. Fine. Stop trying now. Just sit and relax now. Let yourself sink down deeper into the trance. Just relax and go down deeper. My voice will help you to relax and will guide you deeper into the trance. You will listen to me and sink down deeper and deeper.

(To finish up with this test you need to cancel the suggestion that their hands are stuck together.)

Your hands aren't stuck together any more. Your fingers aren't stuck together any more and the next time you try to move them apart they will move easily and simply. They won't be stuck together any more.

A very important thing to note here is that at the beginning of the test I suggested to my partner that their fingers would be stuck together, and then I cancelled this suggestionat the end of the test. Try to get into the habit of doing this because leaving fingers stuck together, feet stuck to the floor and so on can make other tests and activities hard to do.

EYELIDS STUCK TOGETHER. Another useful challenge is to tell your partner that their eyelids are stuck together and then get them to try and open their eyes. This is practically the same as the previous test. Note that here I get my partner to lift their head up so that I can watch them try to open their eyes. The test succeeds when your partner has any difficulty doing this ordinary action. You'll often see them straining the muscles in their forehead, and some particularly responsive people might even try to use their fingers to get their eyes open[20].

20. *I always regard this use of fingers as a good sign of a deep trance.*

On the count of three I want you to lift your head up straight. I don't want you to open your eyes at all, I just want you to lift up your head on the count of three.

One... two... three...

(Watch them lift their head up.)

Good... Your eyelids are starting to stick together now. As I talk to you they are becoming more tightly stuck together. It is as if someone had put glue on your eyelids and glued them tightly together. I want you to feel the glue on your eyelids, between your eyelids holding them together.

OK. I'm going to count to three again in a moment. When I reach three I want you to try and open your eyes. You will feel how tightly stuck together they are when you try and it will be hard for you to open them. I want you to try as hard as you can to open your eyes when I reach three, but they will be stuck together and it will be very difficult to move them.

One... two... three.... Try to open your eyes now.

(Watch them for a moment.)

Good. That's enough. Stop trying now. Lower your head back down and relax. Let yourself relax now. Your eyelids aren't stuck together any more. The next time that you try to open them they will open easily and without effort. The next time you try to open your eyes they will not be stuck together any more.

Relax now and sink down deeper into the trance. You are doing well. Relax and let my voice guide you down deeper and deeper.

THE IMAGINED MEASURING STICK. One of the all-time great difficulties hypnotizing someone is knowing how deep they are. Tests can give you an idea, but they aren't quantitative. A scientific sort like myself likes to have numbers. I like to know whether my partner is deeper in a trance than the last time I hypnotized them, or maybe whether they are more or less in a trance now than ten minutes ago when I first hypnotized them this session.

A good way of doing this is by getting your partner to *tell* you how deep they are. There are disadvantages to this, like they might not have much experience and they aren't really sure themselves. However, they do have the advantage that they are on the inside, so to speak, and where you can only judge by what they do, they can also feel how deeply in a trance they are.

What your partner will tell you cannot be absolute, of course, but they can tell you if they are more or less deeply hypnotized now than some time before. Even this is useful to judge, for example, how well your deepening techniques have worked.

> *I want you to imagine that there is a measuring stick, maybe something like a long wooden rule, hanging in the air in front of you. The stick has markings that go from zero to 100 and even higher. Somewhere along the stick there is a pointer. Its position corresponds to how deeply hypnotized you are, with zero being that you aren't hypnotized at all, and 100 being a very deep trance. I want you to see the stick in front of you and I want you to see the pointer and the number it is pointing to.*
>
> *I am going to touch you on the shoulder now and when I do I want you to tell me the number which the pointer is pointing to. I want you to say it in a loud and clear voice so that I can hear you.*

(Touch your partner on the shoulder and listen to the number they say.)

> *Good. Relax now. You don't need to imagine the measuring stick any more. Relax and go deeper into the trance.*

Step 6 - Planned activities. Before you started the session you should have spent some time with your partner discussing the activities or exercises your were going to do with them once they were in a trance. Now that they are actually in the trance it's time to begin. I'm not going to give any examples here–there are plenty listed later on in the book–but I do want to mention a few things about making life simpler for both you and your partner.

First, take your time. With your partner in a trance the pressure is off and you too can relax a bit. Also, the first few times with someone, make sure that you don't hurry. Spend plenty of time watching how they do the things that you tell them.

Second, don't leave your partner on their own. They might suddenly feel an itch (which I'll talk about below), there might be an emergency, the doorbell might ring, a book might fall off a shelf, or any of a zillion other possible things could happen that might distract or worry them; they're sitting there with their eyes closed and don't know what to do. Be with them all the time.

Thirdly, try and be omniscient. It's very difficult to think of absolutely everything, but the more things you are in control of, the more comfortable your partner will be in giving control to you and the more responsive they will be. I'll give you a trivial example of something that can go not quite right.

Once, when I was hypnotized, my partner had me lift up one arm for some reason or other. Then, when she told me to put it back down it ended up not quite on the armrest of the chair. I was so relaxed and so much in a trance that I couldn't move it myself, but I remember that the position was very uncomfortable and it distracted me from the other things that she was doing with me. It would have been simple for her to get me to move my hand to a more comfortable position (see below), but she didn't notice and she didn't ask.

Watch for signs of restlessness or other movements. Your partner might be starting to feel uncomfortable after being in the same position for a while, or they might be sitting on a fold in their underpants which is beginning to annoy them, or they might have an itch, or they might be thirsty, or whatever. If you do notice restlessness the simplest thing is to ask your partner what's wrong and you might do it like this:

I notice that you are a bit restless. I'm going to touch you on the shoulder in a moment. When I do I want you to lift up your head and tell me, in a loud and clear voice, what the problem is. Then, if I ask you any questions about it I want you to answer them clearly.

(Touch your partner on the shoulder.)

I remember the first few times that I wanted a partner to talk to me while they were in a trance. Invariably, because their head was bent over and I hadn't told them to speak clearly all I got was an indecipherable mumble, and then I had to tell them to repeat it. It slightly tarnishes the image of expert hypnotist when you have to cup your ear and go, "Eh?"

It doesn't hurt, by the way, to stop every now and then anyway and actually ask your partner if they are comfortable even if you don't see any indication of restlessness. They might be like me in the example I gave above, and be so relaxed that they don't move or show signs, but still be uncomfortable.

What if your partner says they're thirsty?

I am going to get you a glass of water. I want you stay sitting there until I get back.

Get a glass of water as quickly as possible. It might be an idea, if it's hot, to keep water nearby just in case. (It is important that you let them know what you are doing and what you expect them to do at all times.)

I have a glass of water for you. I am going to touch your shoulder in a moment. When I do I want you to hold out your right hand. I'll give you the glass of water and then I want you to drink as much as you need.

(Touch them on the shoulder. Watch them drink and then, when they finish, take the glass from them.)

Good. Now relax. Let your head fall forward, put your arm comfortably back down and go deeper into the trance. Relax your mind and body and sink down deeper and deeper.

Or they might be feeling uncomfortable:

On the count of three I want you to move and change position so that you are feeling more comfortable. Move your arms or legs or whatever so that you feel more comfortable and so that you can go deeper into this trance.

One... two... three.

(Watch them move.)

Good. Now relax and go deeper into the trance. Breathe deeply and relax.

There's a little trick in the above example: the first paragraph makes your partner implicitly agree to go deeper into the trance by making themselves more comfortable.

It's important to remember that you should eventually cancel all the suggestions that you give your partner while they are the trance. I'll go into this more later, but an example or two here will give you the idea: if you tell build an elaborate fantasy for your partner where you are both lying on an isolated beach, remember to cancel this when you are finished with it. You might forget in the heat of the moment and then later ask your partner – who is still in the trance – to go and get you a drink from the refrigerator. A refrigerator? On the beach?

The same sort of thing applies if you tell them how to feel. For example, if you tell them to feel horny. When the horniness isn't, er, required any more, like at the end of the session, cancel it.

Step 7 - Waking up your partner. I mentioned earlier that I think waking up your partner is one of the things that you should be best at. It's something that, done well, can leave your partner happy, refreshed and bubbling. If it's rushed it might leave them with a slight headache or feeling slightly groggy.

The headache is not a result of being hypnotized *per se.* It can happen any time that someone, like your partner in a trance, is very relaxed and then suddenly jumps up and starts running around doing things. While deeply relaxed their heart and blood-flow will slow down. Waking them up quickly and then having them rushing around straight afterwards can mean that not enough blood is being pumped to their brain–hence the headache. Grogginess occurs when your partner is not quite 100% awake.

Waking your partner is something that you can do at *any* time, even half way through the induction itself or at any time during a session. Sometimes you might need your partner to wake up in a hurry:

21. *Though if I were you, I would have made sure that the telephone was off the hook before I started.*

the telephone might ring and they may need to talk to someone[21], or there could be some emergency.

You might also want to wake your partner up if at the beginning of the session, when you are trying to hypnotize them, nothing seems to be happening, or if the tests aren't working. It can be a good idea to simply wake them up and then ask them if they know what it was that stopped them from responding.

If you are in the middle of a session and aren't sure what to do next, a wakeup can be a good answer.

Some people have trouble remembering what happens to them while they are hypnotized. This is nothing to worry about in itself, but you might find your partner feeling uneasy or reluctant to be hypnotized if this happens regularly. After all, what's the point in having all these wonderful experiences if you can't remember them afterwards! This problem also makes a good debriefing anywhere from difficult to impossible. In the script below I include a post-hypnotic suggestion or two to help solve this.

A good wakeup gives your partner a chance to refocus on the world. It's also an opportunity to cancel any leftover commands or suggestions that you gave your partner while you were working with them. Some people come out of trances quickly, some need a little more time. I like to give my partners plenty of time and I do it slowly like this:

I am going to wake you up in a moment. I am going to count slowly to ten, and as I do you will come out of this trance. By the time that I reach ten you will be wide awake and feeling refreshed. Any suggestions or instructions that I gave you during the trance will be cancelled as I wake you so that they will be gone completely by the time you are fully awake.

Once you are awake you will be able to remember everything that happened to you during the trance. You will be able to remember clearly the physical feelings you had, the thoughts that you had, what we did together, what we talked about and so on. When you wake up it will all be a clear and vivid memory.

As I count you will feel yourself rising out of the trance. You will feel your mind becoming clearer and you'll feel normal muscular tension and energy returning to your body, your arms, yours legs and your neck, shoulders and head. At the count of ten you will open your eyes and you'll be wide awake.

OK. One... two...

Your are starting to wake up now. You can feel yourself starting to come out of the trance.

Three... four...

You are waking up more and more now. As I count you are coming out of the trance and you'll soon be wide awake.

Five... six...

Your mind is becoming even clearer now. You are coming out of the trance, waking up more and more. Energy and muscle tone are returning to your body.

Seven... eight...

Nearly awake now. You are nearly awake.

Nine... TEN.

Okay. Open your eyes. You are wide awake now.

(Pause.)

How to you feel?

Note that all the talking between the counting gives your partner plenty of time to wake up.

The very last bit of that script – the question – is very important. Ask your partner how they feel. Listen to how they answer. If they seem a little groggy you might have gone too fast. Wait a minute or so and then try again.

Once your partner is awake, sit with them for a few minutes. Don't rush them to do other things. Let them settle back into reality a bit before challenging them to solve the problems of the universe.

WHAT TO DO IF THEY DON'T WAKE UP. They're probably asleep – particularly if they're snoring. Either shake them vigorously, manhandle them to bed, or leave them where they are to sleep it off.

If you have been particularly devious during the session and tried to give your partner a post-hypnotic suggestion which they really don't like, then they might refuse to wake up. Cancel the post-hypnotic suggestion and then do another wakeup.

Step 8 - Debriefing. This step is amazingly important, and many people neglect it. If you have just hypnotized your partner and things went differently to the way you thought they would it can be tempting to ask yourself why. A better thing to do is ask your *partner* why. They were there, you know. Discuss each session with your partner and find out which were the things you did which helped, and which were the things that hindered. Try and hold your debriefing within, say, 24 hours while the memories are still fresh.

Here are some questions you might like to discuss with your partner. Both of you should answer, and the answers should include *why*.

1. What was good about that session?

2. What was not good about that session?

3. What did I do that worked?

4. What did I do that didn't work?

5. What did I do that got in the way or proved to be distracting?

6. How can I change what happened so that it works better?

7. How do I feel about what happened?

8. Am I looking forward to doing this again?

Use the answers to plan your future sessions.

The First Session

ITHOUGHT that it would be a good idea at this point to walk you through a simple session. This will show you one way that you can put all the pieces together.

Attitude is exceptionally important. What you are trying to doe with hypnosis is to add more intimacy, fun and variety to your sex life. It should not be so important to you that your self-image is affected when exercises don't go the way you plan. Regard it as something interesting, fun and exciting to explore.

WHEN YOU ARE GOING TO BE HYPNOTIZED. When you are the one being hypnotized there are a number of things that you can and should do to try achieve the best trance and most satisfaction from the session:

1. Go to the bathroom first!

2. Before the session starts, talk everything over with your partner. Make sure that you know exactly what they are going to do. If you are concerned about anything say so. It is important that you feel comfortable about the session so that you can fully relax.

3. At the beginning of the session, make a serious effort to find a comfortable position and then do your best to relax physically.

4. During the part of the induction where you focus your attention on something do your damnedest to put everything else out of your mind. Focus as though your life depended on it.

5. Don't try and analyze. Once the session starts, try to relax your mind as much as possible. Don't think about what is going to happen next, don't analyze what your partner is doing or saying, and don't analyze what you are feeling. Simply follow instructions and let it happen.

6. Don't anticipate. It's important for you to give up control and let your partner do the driving. Accept the order in which they do things and the speed at which they go. If you have problems talk to your partner about them during the debriefing.

7. Don't get agitated. Maybe it doesn't go the way you expect. Maybe it doesn't seem like anything is happening. Being a good subject is a learned skill for the vast majority of people. Take your time.

Many people have trouble knowing when they are in a trance. As far as they can tell they are wide awake, though maybe just feel that they were very relaxed. The first time I was hypnotized – which was when I was studying hypnotherapy – I went into a deep trance, but at the time I was sure that I hadn't been hypnotized. The only thing I noticed was that my eyes didn't focus when I was told to lift my head up and open my eyes.

When the woman who hypnotized me woke me up the other students in the room were quite concerned that I was fully out of the trance because it had seemed so deep. I couldn't understand why because I was still sure that I hadn't been hypnotized.

Later on I realised that during that session I also hadn't been aware of any of the other people in the room, any of the noises in the room or any of the traffic noises from outside of the room. I also realised that my eyes *always* focus when I open them normally, and that while they were open during the trance there had been only a blur in front of me and that I hadn't cared about it or even tried to focus. All these things are good signs of a deep trance.

WHEN YOU ARE GOING TO HYPNOTIZE YOUR PARTNER. When you are the one doing the hypnotizing it seems like you are the one

doing all the hard work. To some extent this is true because you are one making the decisions and exerting the control during the session. Don't underestimate the contribution of your partner though. You only have as much control as they give you, and remember that for many people it is hard (though often very pleasant or even exciting) to give it up.

To make your first sessions easier to handle keep these points in mind:

1. Discuss the planned session with your partner. Make sure that you agree on the technique you are going to use to hypnotize them and on the exercises and activities you will do during the trance. Go into detail. This benefits both of you in that there will be no surprises.

2. Plan everything, maybe walk it all through in your mind before you start, and make sure that you understand the steps involved in each of the exercises, including what you will be doing and saying, and what your partner will be doing and what help they'll need from you to do it.

3. Take your time. It's good to know the right words to say all the time, but a few pauses every now and then to collect your thoughts won't cause any problems. In any case, your partner will not be looking at you and won't be able to tell whether the pause is intended or not.

4. Make sure that it is clear in your mind how you wake someone up from a trance.

5. Relax. The first couple of times can be very nervewracking. It will come to you.

6. If it's your first time hypnotizing your partner, accept that you are going to be nervous, that they are going to be nervous and that it might not go the way you planned. I find it best to regard each session as an exploration. I have plans that I'd *like* to try, but maybe something else will come up along the way that will be more interesting, or maybe I'll realise that my partner – for whatever reason – isn't going to go into a deep trance that day, or maybe the mood is just simply not quite right. Regardless of what happens, you are spending

time exploring with your partner. This is *quality time*. Don't let expectations mess it up.

PREPARATION. Pick a quiet room with a nice, comfortable chair where your partner will be able to sit without becoming restless. The room itself should not be brightly lit, so close the curtains if the sun is shining in or turn down the lights. The chair your partner sits in should be facing away from any light.

The temperature in the room should be comfortable. If it happens to be hot anyway make sure that your partner has a drink – you don't want them to be distracted by thirst when you are trying to hypnotize them. Make sure that you too have a glass of water handy – lots of talking can make your throat dry.

Both of you should go to the toilet–not necessarily simultaneously. Neither of you will be able to concentrate well with pressing bladder problems.

Allow for the first session taking at least an hour. You won't spend all that time hypnotizing and then waking up your partner, but you will need time to discuss what's going to happen before you start, and then discuss what did happen when you finish.

Take the telephone off the hook, disconnect the doorbell, put a "Do not disturb" sign on the door, give the maid the afternoon off, take the cake out of the oven, give the kids some money and send them to the movies, tell your friends you are going on holidays to Europe and generally arrange not to be disturbed by *anything*.

What you are going to do
1. Hypnotize your partner
2. Then wake them up
Don't plan on anything else for the first session.

HOW YOU WILL FEEL AFTERWARDS. Your partner, who you hypnotized, should feel pleasantly relaxed at the end of the session.

You, who hypnotized your partner, might feel like a drink if you had really been concentrating hard on getting it right. The first few times I hypnotized someone I was very nervous and came out at the end of it feeling very frazzled and exhausted. Mostly I think that it was performance anxiety, pressure that I had applied to myself (in

large quantities). In any case, hypnotizing someone, staying on top of everything that happens, is hard work. Plan for a little sit down, if nothing else, afterwards.

LET'S DO IT. Both of you make yourselves comfortable. Position yourself so that you are in front, but to one side, of your partner so that you can watch their face as you hypnotize them.

In the previous chapter I dissected an *open-eye* script as I explained the procedure. One of my goals for this book is to give you as much practical information and as many different techniques as possible, so, while I could just put the dissected script back together and use it here, instead I'm going to give you a new and different script.

The technique I am going to use here is *closed-eye*, i.e., your partner has their eyes closed right from the start. In particular I am going to use the *setting sun* image – also mentioned in the previous chapter – as the focus of attention.

Start out by checking that your partner is not wearing any tight clothing. Ask them to loosen their belt if it's tight, to undo their shoe-laces, and maybe even remove their shoes. Get them to sit comfortably without arms or legs crossed, and with their feet flat on the floor. Get them to place their hands palm-down on their thighs.

Guide them – and yourself – through a quick relaxation exercise. I like the *three-deep-breaths* one to start:

I want you to take three deep, slow breaths with me now. Each time you breath out I want you to try to relax and settle yourself down in the chair a little more.

OK. Breathe in... Now breathe out.

Breathe in... Now breathe out and settle into the chair.

Breathe in... Relax and breathe out.

Breathe normally again.

And you can follow this by the *stiffen-and-relax* exercise:

Now, hold your right arm straight out in front of you. Tense the muscles all the way down from your shoulder to your fingers.

Make you arm as stiff as possible... Good. Now relax it and put it back on your lap.

Now do the same with your left arm. Hold it out. Stiffen it... Good. Relax it and put it back on your lap.

Stick your right leg straight out. Tense the muscles in it—make it as stiff as possible... OK. Relax it and put it back down.

Same again with the left leg. Hold it out stiff... Good. Relax it and put it back down.

(Make sure that you partner has both feet flat on the ground again here.)

Now tense the muscles in your shoulders. Lift them up and make them tense and stiff... Good. Relax them and let them sink down as far as they'll go.

Now squeeze up the muscles in your face. Squeeze your eyes tight together. Tense the muscles in your cheeks. Bite together... Good. Relax again.

Finally, tighten the muscles around your tummy and diaphragm. Tighten them as much as you can... Good. Relax.

Now quickly summarise to your partner what you are going to do:

OK. I'm going to hypnotize you now by getting you to focus on a scene in your mind where you're sitting on a beach at the end of the day and the sun is setting. As you watch the sun go down you'll sink into a trance.

Once you're in the trance, I'll spend a little time deepening the trance and then I'll try to get some idea of how deep you are by getting you firstly to lift up your head and open your eyes, and then I'll use the measuring stick test.

After that I'll wake you up.

Describe the scene which you them to imagine:

Imagine now that you are sitting comfortably at the beach facing out towards the sunset. There is no-one else around. It's quiet,

peaceful and relaxing, and the temperature is quite pleasant. Just a few small waves are washing up onto the beach. The sand is clean and uncluttered. There's a very gentle breeze moving across the water, blowing slowly past you and through the trees nearby. The sky is a nice, clear blue, and the sun is large and red in front of you but isn't so bright that it hurts your eyes. You can look at the sun directly without straining or hurting your eyes. In fact, that's what I want you to do.

Now we begin the *future tense* step.

I want you to concentrate on the image of the sun. I want you to focus your mind as completely as you can on the sun sitting there above the horizon. Try and get rid of any other thoughts that you might have so that all there is in your mind is the image of that setting sun.

Soon, as you focus on the sun, your mind and body will begin to relax, to relax even more than they are now. Your arms and legs will become slightly heavy as the muscles in them relax.

Your neck and shoulders will begin to sag as the tension drains away from them. Your head will become heavy and start sinking down towards your chest. You'll feel your tummy begin to settle as your diaphragm relaxes, and your whole body will slowly settle and sink down deeper into the chair.

I want you to continue to focus on the image of the setting sun, and as it slowly sinks down you'll also sink down with it, sink down into a deep and relaxed trance.

As you go into this trance your mind will also settle so that the only things it will be doing are listening to my voice and seeing the sun slowly settling down behind the horizon. My voice will help you to relax and to get rid of all your other thoughts and any other worries that you might have which are distracting you.

You'll feel the tension draining out of your fingers, your hands, your wrists, your forearms, your upper arms and your shoulders.

Your arms will become slightly heavy as all the muscle tension in them fades away. They'll become completely relaxed and limp.

The same thing will happen to your legs. Your toes, feet, ankles, calves and thighs will relax. You'll feel them become a little heavy and sag as the muscle tension drains away from them.

Your mind will also relax. As it does the clutter of thoughts will settle down, your mind will quieten and become calm and peaceful. All there will be in it is my voice and the image of the sun, slowly going down and helping you go down too, into a deep trance.

Each time you breathe in and out the regular movement of your chest will help your body settle. The regular breathing itself will relax you, and it might seem that each time you exhale a little bit more of the tension in your body gets breathed out with the bad air.

My voice will help you and guide you into this deep relaxation, this deep trance, where you'll listen to, and respond to, everything I say to you.

You may need to repeat this, or ad lib your own phrases, until your partner starts to respond. Look for twitching in their hands, shoulders or elsewhere as their muscles relax. Their head might also start to sag forward, and you may notice their breathing become slower and more regular.

When it's clear from these or other signs that your partner is starting to respond/relax it's time to move on to the *present tense.*

This future tense phase can go for seconds or minutes. If you don't see any signs of relaxation after about 15 minutes, do a wakeup[1] and then talk to your partner and find out what they were thinking and how they were feeling. It might be that they were having trouble imagining the scene, or that they became aware of a lump in their chair, or they suddenly remembered that they had an appointment or that they had forgotten to do something, or they suddenly became nervous and

1. *This is <u>very</u> important! Although there might not have been any outward signs that they were going into a trance they could actually be in quite a deep one.*

needed some reassurance before being able to go on. Talk to them about it, resolve the problem and then try again.

You don't have to try again immediately. Don't pressure yourself to do so. Regard it as an educational experience, make an appointment with each other to do it again maybe the next evening and then move on to some serious snuggling instead.

Another problem you might have is that your partner responds faster than you expected. The general idea that I've expressed so far is that when you hypnotize your partner is mostly that you guide them into a trance. I have had one or two women who literally raced off ahead of me and I have had to struggle to keep up! The future tense phase with them lasted less than a few seconds. This can be a little disconcerting.

When this happens it demonstrates that it really is your partner who puts themselves into the trance. When their level of expectation and responsiveness is high it can happen almost instantly.

So, once you see clear signs that your partner is starting to respond to your suggestions it's time to start including the present tense in your soliloquy.

You're starting to relax now. You can feel the relaxation beginning to spread through your body. The tension is draining out of you, and as it does you'll sink into a trance where you'll respond completely to what I say to you—to the suggestions and commands that I give you.

As you keep focusing on the image of the sun which is slowly setting behind the horizon you'll sink down with it. Your mind will become more and more relaxed and empty.

The sound of my voice is helping you to go down. It's guiding you into the trance. I don't want you to fight it in any way. I want you to let yourself slip into the deep and calming relaxation where I'll take care of you.

The muscles in your arms and legs are becoming heavier, and the muscles in them are relaxing. The muscles in your shoulders and neck are also relaxing and your head is slowly falling forward

onto your chest. Let it fall down. I don't want you to resist it. Let it sink down, and as it does you'll go into the trance.

Your breathing is becoming more regular as your whole body calms down, and the normal physical tensions that you have from doing the things that you have done today up 'til now are fading, letting you feel completely at peace.

As you go into the trance you'll become more and more responsive to what I say to you. More and more you will think and feel and do what I tell you.

Keep imagining the sun there, and watch it slowly sinking down. The lower it sinks the more you sink down towards a pleasant, relaxed trance. As it sinks down so do you. You relax more and more. Your mind relaxes and becomes empty, and the words I say become more and more a part of you, going deep into your mind.

Your neck muscles are relaxing and your head is sinking down, down towards your chest as it becomes heavier and as your neck and shoulders relax.

As with the future tense section, you may need to repeat or ad-lib here for a while.

One of the things that I found hard to do when I first started practicing hypnosis was knowing when my partner was in a trance so that I could start with the deepening and testing phase of the induction.

After a lot of thought and head-scratching what I'm going to say about that is this: I can give you some things to look for that will be good clues that they are in a trance, but it's ultimately something that you are going to have to learn by experience.

There really isn't a point where your partner suddenly goes from not being in a trance to being in one. It's a gradual progression – they relax and sink into a trance. For some of the time at the start of the induction they're just going to be relaxed. For some of the time after that they'll be a little bit hypnotized, but not enough for testing or doing anything, er, useful... and then later they'll be in a deep enough

trance so that you can do horrible, disgusting, perverted (and fun) things to them. Where they are at any particular point is something you'll just have to learn to "feel."

Things to look for are: shallow breathing, their head has slumped forward onto their chest and has stopped sinking down (their head might not be actually resting on their chest because some people's heads just don't go down that far), they just generally have a slumped or relaxed posture, or when you look at their (closed) eyes you cannot see any movement behind the eyelids.

What I generally do with someone new is stay in the present tense phase while they continue to show signs of deepening relaxation, e.g., their head keeps sinking down, or their breathing is still settling, or there are still occasional twitches in their hands or feet and so on. When there's been no change for about a minute or so I usually consider that it's time to move on.

> *You're in a trance now. Stop imagining the sunset and concentrate on just my voice. You'll sink deeper into the trance as I talk to you. My voice will keep helping you to go down deeper and deeper, and you'll respond completely to what I say to you.*

Start the testing with simple and non-demanding tests and work up. About the simplest test that you can do is just lifting your partner's arm to feel how relaxed they are. It's always a good idea to tell your partner what you are going to do so as not to surprise them. In a light trance something unexpected can bring them out of it.

> *In a moment I'm going to lift up your right arm to feel how relaxed you are. Then I'm going to put it back down so that you can continue to go deeper into this trance.*

(Pick up their right arm by the wrist. Gently move it a little to see if there's any muscle tension. Ideally it should be completely limp. Then lower it back to where it was, making sure that you leave it in a comfortable position.)

> *Good. Go deeper into the trance now.*

After each test do a little bit of deepening. This is simply settling them and talking them deeper into the trance. Something like the

following is good, but each time you use it vary it a little with other words and phrases from the future or present tense scripts:

I want you to just focus on my voice now. I don't want you to think of anything else. Your body and mind are relaxed, and as I continue to talk to you your mind will become more and more focused on what I say. There's nothing but my voice. Continue to relax and to sink down deeper and deeper into the trance. Deeper and deeper.

You might find that when you do a test it simply doesn't work. If things don't seem right (like, for example, if you do the above test and their arm is stiff, or if you feel them pulling against you) or you don't feel comfortable for any reason it's a good idea to end the session. Wake your partner up[2] and talk to them about what happened. There's no need for you to have 100% success on the first attempt, and when you do have doubts it's best to err on the side of comfort and confidence in what you are both doing. You can always go back and try again later.

For this first session what you've done is enough. Your partner is now in what's probably a light trance. You might want to do one or more of the tests that I mentioned in the previous chapter, but after that I'd recommend waking your partner up and then discussing with them how it went.

Running through a hypnosis session smoothly is a skill and I'd like you to slowly develop that skill rather than have you rushing in, trying something that you aren't prepared for, and then messing up and losing confidence in yourself and in what we're trying to achieve here.

I'm going to wake you up now. I'm going to slowly count to ten, and as I count you'll come out of this trance. By the time I reach ten you will be wide awake. Once you are awake I want you to be able to remember clearly everything that happened so that we can talk about it later.

2. *As always, let them know when you do something that they're not expecting like waking them up early. You could say something like this before doing the wakeup itself: "I'm going to wake you up now so that we can talk about how you have been reacting so far." Or, "I'm going to cut this session short and wake you up now so that I can talk with you about how it's been going."*

Now I'm going to start counting and as I count you will feel yourself coming out of the trance. Any heaviness in your body or your arms and legs will fade and your breathing will become deeper. By the time I finish counting you will be wide awake, and feeling refreshed and pleasantly relaxed. You will be fully under your own control again.

One... two... You're starting to wake up now. The trance you're in is getting lighter and soon you'll be out of the trance and awake again.

Three... four... You're waking up more and more now. Energy is returning to your arms and legs and you're becoming more aware of the feelings and sensations in your body.

Five... six... You're getting closer and closer to being awake. You're coming out of the trance and soon you'll open your eyes and feel relaxed and refreshed.

Seven... eight... Nearly there now. You're nearly awake. You can open your eyes in a moment and then you'll be wide awake.

Nine... TEN! You're awake now. Open your eyes. Wide awake.

Now that your partner is awake, sit with them a bit. Let them reorient themselves to reality before asking them too many questions. There is however one question which you should always ask shortly after each trance, and it is: "How do you feel?" Listen carefully. How your partner answers, as well as what they answer, will tell you a lot about how well the session went.

Spend some time talking to your partner about what happened. This is debriefing time and using it properly – i.e., asking the right questions, listening to the answers and using them in future sessions – will speed your progress enormously.

Ask your partner (and yourself) about what went right and what could have been done better. Then ask how they felt before you started as well as once you'd awakened them. Ask them what they'd like to do more of, what they'd like to do less of, and how clear their memories are of what happened and how they felt at the time.

Have a cup of coffee, relax and pat yourself on the back for a job well done.

Exercise Program

OK, YOU'VE hypnotized your partner. What next?

Before getting into any of the sexy stuff it's a good idea to do a bit of practice hypnotizing your partner, and to get a *feel* for how they behave in a trance and how well they will respond to your suggestions and commands. At the same time as you practice hypnotizing, your partner practices being hypnotized. This is important because it generally takes three or four sessions, even with a trained therapist, for someone to be able to settle into a nice, workable trance. After this practice you will both be able to start doing the sexual exercises in later chapters feeling completely comfortable with what you are doing.

In this chapter I'll give you some exercises which you can do with your partner. The exercises will have them moving, walking and talking, and doing simple, and then progressively more demanding tasks, so that they learn both how to listen to and follow your commands, and how to stay in the trance while doing them.

It can be easy to "shock" someone out of a trance, particularly someone who isn't very used to being hypnotized. It can happen, for example, when there are loud noises, long periods of silence or when they become confused. By "building up" your partner with exercises they'll be more comfortable when you get onto the more interesting bedroom exercises later on.

BECOME COMFORTABLE HYPNOTIZING AND WAKING YOUR PARTNER. The first thing that you need to do before any of the exercises in this chapter, or those following, is become comfortable both hypnotizing and waking up your partner. This is what you did in the "first time" chapter earlier and I would like you to go back and repeat it a few times – spread over a number of days – until you feel completely at ease both with the different steps and with your partner's responses.

LIFTING THEIR RIGHT ARM.

On the count of three I want you lift up your right arm and hold it straight out in front of you.

One... two... THREE.

(Watch them lift their arm. Wait a second or two after it's horizontal. Notice the position of their hand and fingers, and note how stiff their arm is, if at all.)

Good. Now put your arm back where it was.

Simple, eh?

LIFTING THE HEAD. Now let's get their head up, just like in one of the earlier tests:

On the count of three I want you to lift your head up straight and open your eyes. I don't want you to wake up, and you don't have to look at anything, I just want your head up and your eyes open on the count of three.

Then, when I touch you on the shoulder I want you to close your eyes, let your head go back down, and go deeper into the trance.

One... two... THREE.

Watch them lift their head up and open their eyes. Wait a moment and then touch them on the shoulder. Spend a little time deepening them here.

BEING CLEAR AND UNAMBIGUOUS. Notice that I said, "I don't want you to wake up." Sometimes, depending on how you say something,

your partner might get the idea that they're supposed to be awake, or that they're supposed to wake up. This can easily happen the first one or two times that you hypnotize someone when they aren't used to your "style," and particularly in the exercises where you get them to open their eyes. Telling them that you don't want them to wake up just makes things clear.

You may have noticed my propensity for counting to three. There's a good reason for doing this.

Let me set a scene for you: your partner is sitting there, relaxed, a little bit out of it, and doesn't know what you are going to do. You give them the following command:

Stand up, open your eyes, go into the bedroom, take off your clothes and lay them on the bed. Then go into the kitchen, pour me a small glass of whiskey, bring it back here and give it to me. Finally sit back down, close your eyes and relax again.

Now suppose you pause briefly after the first sentence – maybe you get distracted by something, or maybe you forget briefly what you were going to say next and have to check your notes. Your partner will likely start to get up and head to the bedroom to undress. But then you continue with the next sentence and they suddenly realize that they've done something wrong! They shouldn't have moved yet! They should have waited! This immediately creates conflict in their mind.

All you need to do to avoid this, and zillions of other similar conflicts, is to prefix each command with: "On the count of three I want you to...." Immediately they know they'll get a signal when to start.

Of course, you don't want to spend the rest of your life going around saying, on the count of three I want you to scratch my back, or get me a drink, or let me stroke your breasts, or whatever. As you get used to communicating with your partner while they're hypnotized you'll learn how to give commands in an unambiguous way so that you don't need the count. You'll also get used to the occasional mistake when you haven't communicated properly and your partner was wandered off, er, half-cocked, so to speak.

By giving your partner a signal like this you make things easier for them. They don't have to work out *when* to do something themselves. All they have to do is listen and wait for the signal.

STANDING UP. OK. Let's do another simple movement. This time they will stand up. This is not the sort of thing that you should do if they happen to be sitting in one of those extremely comfortable chairs that practically swallow you. Having to really struggle to get out of the chair is something that's likely to frustrate them and, if they're only in a light trance, wake them up unexpectedly. This is why I always like to use simple straight-backed chairs (and, for the same reason, this is the type of chair that you always see stage hypnotists using, too).

> *This time, when I count to three, I want you to get out of the chair and stand up straight. I don't want you to wake up. Just stand up straight and wait for my next instruction.*
>
> *One... two... THREE! Stand up.*
>
> (Wait and watch them stand up.)
>
> *Good. Now, on the count of three, I want you to sit back down, make yourself comfortable again, and then relax.*
>
> *One... two... THREE! Sit down again.*
>
> (Watch them sit down.)

During this exercise your partner should have kept their eyes closed. Because they have no points of reference, you may see them having to feel around behind them a bit with their hands to try find the chair again when they sit down. As an intellectual process, sitting down is more demanding than standing up.

FETCHING A GLASS OF WATER. This is more complex for your partner. It requires them to do a series of actions and make decisions (which glass to use, for example).

> *On the count of three I want you to open your eyes, stand up, go to the kitchen, get me a glass of water, bring it back here, hand it*

to me and then sit down, close your eyes and relax back into a deep trance.

TOILET EXCURSIONS. I mentioned in an earlier chapter that you should make sure that your partner has been to the toilet before you start the session. This is probably also a good idea for you too, and means that you won't have to interrupt your session for a trip to the toilet...

Except real life isn't always like that and, sooner or later, you'll find during one of sessions that your partner needs to go. You'll either find this out because they'll become restless and you'll ask them why and they'll tell you; or else they'll just tell you without being asked.

You can either send them to the toilet awake, i.e., you wake them up and let them go themselves, or if you are more adventurous you can keep them in a trance and send them. There are one or two tricks to this latter.

On the count of three I want you to open your eyes, stand up, go to the toilet and relieve yourself.

One... two... THREE! Stand up and go to the toilet now.

Looks good? Often if you say something like this you're going to end up wondering why they take so long. They take so long because you didn't tell them to come back, and now they're still hanging around the toilet, maybe sitting there, waiting for their next instruction.

Something like this will work better:

On the count of three I want you to open your eyes, stand up, go to the toilet and relieve yourself. Then, when you have completely finished – wiped yourself, washed your hands and so forth – I want you to come back here, sit down, close your eyes and relax again.

Please note that in both these examples I have specifically said that I wanted my partner to open their eyes before going. Leave this out and you'll see your partner, with their eyes still closed, feeling their way along the walls as they try to find the bathroom. This is probably not what you want unless you are feeling a little mean or sadistic.

TALKING. Talking is actually a difficult thing to do. It requires a surprising amount of mental effort to both form a sentence and then to say it out loud. How well your hypnotized partner can do it is a good indicator of how deeply hypnotized they are.

In a moment I'm going to count to three. When I reach three I want you to lift your head up straight, then I'm going to ask you some questions. I want you to think about each question and then answer it as best you can in a loud and clear voice.

One... two... THREE!

The following are some very useful things to ask:

1. How do you feel?

2. Are you comfortable?

3. Do you need to go to the toilet?

4. Are you thirsty?

Don't be surprised if you get answers like, "Good," "Yes" or "No" and then nothing else. When someone is in a trance their mind often functions very simply and directly. You're unlikely to be able to have a brilliantly incisive conversation with them. This is really what you're after anyway – they have given up control to you so they don't need to do any complex planning or be clever.

Keep the questions simple so that both working out the answer and saying it are also simple. Asking them about the relative merits of indirect taxation versus direct taxation, for example, will only confuse them in their relaxed state, even if they have a good grasp of the subject material.

Also, *don't* take the opportunity to ask them about things that they normally wouldn't tell you. They are fully conscious and aware of what you are doing with them. Trying to take advantage of them while they're in this state will only irritate them, possibly bring them out of the trance and make them lose trust in you.

When you have finished asking them questions tell your partner to relax back into the trance and then deepen them.

OK. I've finished asking you questions for them moment. You can relax now and let your head fall forward again. I want you to relax and sink down deeper into the trance. Let your mind relax even more than it has been so far. Relax and go deeper.

WAKING TRANCE. If your partner responds well to what you have done with them so far you might like to try what is called a *waking trance* with them. Simply put, this is having your partner act like they are awake while they are still hypnotized.

This is not the sort of thing which you do with someone who is only lightly hypnotized – telling them to act like they're awake might actually wake them up. Instead you do this with a partner who is responding promptly and who doesn't seem too lethargic and sluggish when following instructions.

The first time you try this, regardless of how well it seems to work, don't keep your partner acting awake for more than a couple of minutes. This is one of the hardest things for someone in a trance to learn to do and you should build up to longer periods and more complex activities slowly.

How much success you have with this will vary in interesting ways.

1. Your partner may not be able to do this at all. They might not even be able to open their eyes fully.

2. They might appear heavy and slow like they are on sedatives.

3. They might act sort of like they're awake, but need prompting to do anything.

4. They might act like they're wide awake at the start – full of energy, laughing at jokes or whatever – and then gradually fade away.

5. They might sit up, act like they're awake and deny that they're in a trance.

6. Or, of course, they might act like they're awake with no problems at all.

On the count of three I want you to lift your head, open your eyes and act like you're awake. I want you to act like you are wide awake without actually waking up. I don't want you to wake up

at all. Instead I want you to act like you're wide awake. You'll feel full of energy, without being sluggish or heavy. You'll be able to talk and move easily while still staying in this trance.

You'll continue to act like you are awake until I touch you on the shoulder. When I touch your shoulder you'll stop what you are doing, sit back down if you aren't already, and then you'll close your eyes, relax and sink down deeper into this trance. You'll stop acting like you are awake when I touch your shoulder and you'll relax and go deeper into this trance.

One... two... THREE!

Spend some time talking with your partner. Ask them a couple of simple questions. Get them to do simple movements. Have them stand up and maybe walk around a bit. Let them have a drink. See how well they do. Watch them closely for the first couple of minutes and compare how they behave while they're in the trance to what they're like when they're awake.

If all goes well and you are feeling comfortable you might like to try a couple of the *challenge* tests given earlier – in the chapter on hypnotizing your partner – to see how well they work. The *stiff arm* test is a good one, as is the *eyes stuck together* test.

SUMMARY. All the exercises in this chapter are fairly simple. Their goal is to help you and your partner get used to hypnosis. Repeat these exercises over a number of sessions so that you feel at ease with hypnotizing your partner, waking them up and working with them while they are in the trance, and so that they feel at ease being hypnotized and working with you. Remember the debriefing after each session.

In the next chapters I'll be getting on to the sexual stuff. It will help you to relax and enjoy what you are doing if you've already got the practice with the basics presented so far.

Post-Hypnotic Suggestion

POST-HYPNOTIC suggestion (PHS) is giving your partner a suggestion or command while they're in a trance which will become *active* after the trance (i.e., when they're awake). Most people's ideas about PHS come from stage and TV shows, and maybe from the movies. Usually these ideas are wrong, particularly about how effective or powerful PHS can be. In this chapter I want to do a bit of debunking and then explain the whys and hows, and the dos and don'ts, of PHS itself.

PHS is one of those really fascinating things that you sometimes come across in life, which turn out to be much more complex and difficult to use than you'd expect. Roughly speaking they come in two varieties:

The first kind is the one most people are familiar with from the popular media. This type is triggered either by some event or at a certain time (e.g., the hypnotist snapping their fingers, or at a certain time of day, or during a certain activity, etc.). When triggered the subject does whatever it is, and then it's all over.

The second kind is often used by therapists and has no trigger. This sort of PHS is designed to change attitudes or behavior in the long-term. It can be used to help people with phobias or anxiety.

There are a few problems with post-hypnotic suggestions:

1. They generally wear off,

2. They are difficult to do right,

3. They don't always work,

4. When they *do* work it might not be as expected.

I have already mentioned the *wearing-off* effect in hypnosis earlier in the book. This comes from your partner's mind rejecting that which doesn't fit into their general pattern of behavior; the more *contrary* a PHS is to that pattern, the faster it will get the boot. As an example you might consider a PHS to, say, dance on the table at a party when a certain song is played. If your partner is a life-of-the-party extrovert the PHS has a good chance of working – it doesn't conflict with the way your partner basically is. If, on the other hand, your partner is a timid introvert, then the PHS has a very good chance of not working at all – the potential embarrassment will get rid of it pronto.

How effective a PHS will be depends on a number of factors:

1. Depth of trance when the PHS is given,

2. How strongly the PHS is given,

3. If the PHS is repeated, how often (daily, weekly?), and how many times,

4. How contrary the PHS is to your partner's personality.

Let me show you now how you *don't* give a PHS. This example here is likely to have an unfortunate side effect:

I'm going to wake you up from this trance shortly, and when I do you will find that you are very thirsty and that you'll need a glass of water.

If your partner was in any sort of trance at all then you'll wake them up and they'll likely ask for a glass of water. This is what you wanted, isn't it?

If you live with your partner you might then become aware over the next days that they are drinking a lot more water than they used to. They might even comment about being thirsty a lot of the time. Hmmmm.

The problem in this case is that the PHS doesn't say anything about when it's supposed to *stop* being effective. This is what can happen when you're not precise.

Now. What about this one:

Whenever you hear the song, "Love Potion Number Nine," you'll stop whatever you're doing and you'll do a sexy striptease.

Or what about:

Any time I snap my fingers you'll go into a trance.

The striptease PHS suggestion suffers from the problem that your partner is likely to – sooner or later – hear the song when they're at work, in a shop, or just generally somewhere in public, and when you're not around. The snapping-your-fingers suggestion is, on the other hand, a bit general and could be triggered when someone *near* you snaps their fingers, particularly if your partner is looking in another direction, or if you happen to say something like, "It's a snap!" and do the gesture that goes with the phrase. Better ways to give these two post-hypnotic suggestions would be:

Whenever we are alone and somewhere private and you hear the song, "Love Potion Number Nine," you'll stop whatever you're doing and you'll do a sexy striptease.

Or:

Any time I snap my fingers while I'm touching your shoulder you'll go into a trance.

I was recently reading about the activities of a woman who uses hypnosis with her male partner. One of the things she does – which you could possibly categorize under the heading of *erotic control* – is to regularly give him a post-hypnotic suggestion that he'll be unable to have an erection except with her. This is all fine and dandy, and maybe keeps him from "straying," but what about when and if they break up and he finds another woman? The chances are good that he'll have trouble having an erection with his new lady and could need professional therapy to get rid of the PHS.

A good post-hypnotic suggestion will be:

1. Well-thought out with the consequences understood,

2. Clearly and concisely expressed,

3. Well-defined with an unambiguous trigger,

4. Limited in scope.

Back in the chapter where I explained in detail how to go about hypnotising your partner I included the following paragraph in the script used to wake up your partner:

I'm going to wake you up in a moment. I'm going to count slowly to ten, and as I do you'll come out of this trance. By the time that I reach ten you will be wide awake and feeling refreshed. Any suggestions or instructions that I gave you during the trance will be cancelled as I wake you so that they'll be gone completely by the time you're fully awake.

The last sentence is designed to prevent unintentional post-hypnotic suggestions. When you start using PHS with your partner you'll need to either leave out this sentence out or, better, replace it with something like:

The post-hypnotic suggestions that I've given you during this trance will be fully effective once you are awake.

Let's have a look at an example of a "good" post-hypnotic suggestion:

Whenever we're alone and in private somewhere and I say the phrase, "I love melons," you will have an uncontrollable desire to show me your bare breasts. You'll show me your bare breasts and then, a few seconds later, the uncontrollable desire will suddenly disappear.

This PHS can be fun because you can surprise your partner with it any time that you are alone together; maybe in your partner's office, for example. Of course, this particular PHS is meant for use on a female partner, but you should be able to easily make changes if your partner happens to be male.

Please examine the PHS carefully. Note how I was careful to specify in what situations it can be triggered so that if, for example, you were

at the fruit-market with your partner and mentioned melons, an embarrassing scene would *not* ensue. Rather than letting the "uncontrollable desire" fade away in who-knows-how-long, I also said how long the PHS should last once triggered. Finally, while not extremely rare, the trigger phrase is one that you wouldn't use every day.

When giving your partner a post-hypnotic suggestion I recommend repeating it a number of times during the trance with a bit of deepening between each repeat.

CANCELLING A POST-HYPNOTIC SUGGESTION. Suppose you've had your bit of fun and you now want to get rid of a PHS which you gave your partner. It doesn't matter what sort of post-hypnotic suggestion it is, or how long ago or how recently you gave it to them – cancelling a PHS is simply a matter of hypnotizing your partner and telling/commanding them that the PHS will no longer be effective. There are two things to note here:

1. You must unambiguously identify the post-hypnotic suggestion which you want to cancel,

2. You may need to go through the cancelling procedure a number of times, particularly if you gave your partner the PHS very strongly or forcefully in the first place.

Here's how you can cancel the post-hypnotic suggestion about the melons:

From now on the post-hypnotic suggestion that I have given you about baring your breasts to me when I say the phrase, "I love melons," will no longer have any effect on you. It is cancelled now. When and if you show me your breasts is again completely up to you and no longer anything that I can hypnotically trigger with any phrase.

UNCANCELLED POST-HYPNOTIC SUGGESTIONS. Post-hypnotic suggestions that don't work properly, or those that haven't been cancelled and are fading away, still have an impact on how your partner thinks, feels and acts when they are triggered. How big an impact this actually is will vary according to many of the factors I've already men-

tioned. Typically this involves a feeling that they should be doing something, and they might:

1. Do what the post-hypnotic suggestion said they should do,

2. Know what they should be doing according to the post-hypnotic suggestion but they try to suppress it and end up distracted,

3. Know that they should be doing something, but not know that it's a result of a post-hypnotic suggestion and wonder why they feel like doing it,

4. Know that they should be doing something but not know what,

5. Have a feeling that there's something they've forgotten or that something's wrong.

Often the result is confusion or distraction.

INSTANT TRANCE. The idea of giving your partner a post-hypnotic suggestion so that they go into a trance on a signal, rather than you having to do a full induction every time, is appealing. Here is an example of how you can do it:

In future, when I touch you on the shoulder and at the same time say the phrase, "Go into a trance now," you'll stop what you are doing, close your eyes and sink into a deep trance. If you're sitting or standing at the time you'll stay upright while you'll still sink into the deep and relaxed trance.

So, when I say, "Go into a trance now" and touch you on the shoulder you'll go into a trance, into a deep trance. I don't want you to go into a trance if I just touch you on the shoulder, or if I just say the phrase. You'll only go into a trance when I do both together and, when that happens, you'll go into a trance as deep or deeper than the one you are in now.

You'll probably need to give your partner the above PHS over a few sessions before it becomes completely effective. Once it does it can save you a lot of time when you decide to use it, and it can be fun to surprise your partner when they're least expecting it. I would sug-

gest that you repeat the PHS from time to time – maybe monthly – to reinforce it.

Let's Talk About Sex

LISTEN. When you get right down to it, this book is all about – forgive the play on words – you and your partner having a fucking good time. Sex, I think, can be absolutely brilliant. In any encounter the focus can be on fun, or on intimacy, or on sensation. Sometimes you might have one of those wonderful sessions in which all your nerve endings are alive, all sending little joy signals continuously back to your brain. Sometimes too it's just nice to spend time exploring each other, luxuriating in the caresses of your partner. Sometimes you can end up playing and laughing so much that sex is forgotten and simple fun and rolling around becomes the order of the day.

From now on in this book the focus is on sex. In the first chapter I mentioned some of the ways that you can use hypnosis to make your sex life more, um, "interesting." I want to remind you of these briefly:

1. To relax your partner and free them from any distractions,

2. To focus their minds on the action,

3. To decrease their inhibitions, thus increasing their "range,"

4. To create or enhance their sexual fantasies, thus making them more sexually aroused,

5. To help them immerse themselves more fully in role-playing games,

6. To enhance their physical sensitivity and sexual responsiveness,

7. To create new and exciting feelings or to create new erogenous zones,

8. To explore sexual or erotic control.

On top of these you can have hypnotic fun and games like not letting your partner have an erection until you say, making them incredibly sexually aroused in a department store, or by making them sexually aroused and not letting them take off their clothes.

Just like earlier in the book with the plain hypnosis exercises, the sexual exercises start off simply and work up. I *do* suggest that you try to more or less follow the order that I give here. If you try the more demanding exercises too soon, you might find that unfamiliarity and pressure to perform inhibit either you or your partner.

You need to work at good sex, whether or not you use hypnosis. Sure, there are some nerve endings that are going to have a good time almost regardless of what you do to them, but really great sex needs to be worked at: expectations need to be created, tension needs to be built, pink bits need to be stroked, and so on.

SIMPLE TOUCHING AND AROUSAL. A nice exercise to start with is having your naked and hypnotized partner laying down on the bed while you stroke them. At the same time you get them to focus on the feelings coming from your hands as you touch and explore them. There are two big pluses to doing this exercise: the first is that your partner gets the chance to respond to your touch with all the heightened sensitivity and lack of distraction that a trance can bring. The second is that by the end of the exercise they can be so horny that wild horses won't be able to stop them jumping on you.

For you, the exercise can be sexually frustrating at the beginning; you can see and feel your partner becoming very aroused and you can't, er, take advantage of this arousal straight away. Don't worry. You'll get your reward when your partner is awake again and is still "suffering" the effects of your attention.

I recommend that you have your partner undress and lie down before you hypnotize them. The reason is that the mechanics of un-

dressing and walking around can be distracting and can negatively affect the depth of trance. This can be a problem if your partner can only go into a light trance, so have them naked and horizontal before you start.

Something that's not obvious is that while your partner is so relaxed and so focused on what you're doing, it can be difficult for them to communicate with you. You may have noticed times yourself when except for one tiny thing, everything is going perfectly. So perfectly, in fact, that it's difficult to interrupt proceedings to actually mention the problem. I would suggest that you arrange a small set of signals with your partner that they can use to let you know, for instance, if what you are doing to them is chafing, or if they need to move their legs. You'll see how I do this in the following script.

I like to talk quietly to my partner while I am doing this exercise. I find that it helps them if I guide their focus to where I'm touching and it also gives them more of an awareness of my presence. Your partner might instead find that talking distracts them from concentrating fully on their feelings. Experiment and find what works for you both.

> In a little while I'm going to start touching and caressing you. When I do I want you to concentrate on the feelings that you get from me. I want you to focus on the sensations, and I want you to let yourself open up to them and respond to them.
>
> If, at any time, there's something uncomfortable or unpleasant for you in any way, I want you to let me know by closing your right hand. That will be your signal to me that something is unpleasant. I'll then find out what it is from you and then do what I can to fix it.
>
> Also, if you feel that there's something you really want me to do you can signal me by moving your right hand from side to side. Then I'll ask you what it is.
>
> Finally, if it happens that you start getting close to orgasm I'd like you to clench your fist to let me know.

Now I'm going to start touching you. I want to feel and respond to just the sensations that I give you.

Feel my hands stroking your forehead now. My hands and fingers are stroking and caressing your forehead... and are now moving down to your cheeks and to your lips.

Now I am moving my hands down to your neck. I don't want you to think of anything except the way I'm touching you. Just focus on the sensations.

My hands are on your shoulders. Feel the warmth of my hands as they move over your skin.

My fingers are caressing your breasts and your nipples. I am lightly stroking and caressing your nipples.

While you are touching your partner watch them closely. As well as the signals they might consciously give you (i.e., by moving their hand as you told them) you should watch their facial expressions, the way they breathe, and pay attention to any squirming and any gasping and/or grunting sounds that they might make. Everything they do and every sound they make will help you understand "where they are."

It is entirely – and happily – possible that your partner could become so turned on that they'll want you to climb on and join in the festivities. They will signal when they're ready.

It is also often a very good idea to have them to take your hand and guide it to show you where and how they want to be touched.

BODY-TO-BODY CONTACT. There's no reason why you and your partner can't make love while they are in a trance. It's simple enough and the only things that you have to remember are:

1. that you partner is in trance and that you need to retain control,

2. don't go to sleep before waking them up from the trance at the end.

One of the great clumsinesses[1] of love-making, I think, is the undressing bit – with the hopping around on one leg taking shoes and

1. *Plural of the noun, "clumsiness."*

underwear off, buttons sticking and zippers catching bits of hair or sensitive skin. It always seems that this part of sex is designed to break the mood. The same can happen with your partner in a trance. You might have worked hard to focus their attention on all the touchy-feely bits and then they have to shift it to their clothes. Like with the previous exercise I suggest that you get the clothes off right at the start so that you've got one less worry and one less impediment when *the time* comes.

Now your partner is simmering along nicely — maybe writhing under your hands on the sheets — and you decide that you don't want to wait any longer. What do you do?

I'm going to count to three in a moment. When I reach three I want you to open your eyes and start making love to me. You'll feel the hunger and passion in your body and you'll let it out with me. You'll love me, and touch me, and fuck me as hard or as gently as you want.

You'll open your eyes on the count of three and make love to me. You'll move and change position and talk to me as you need. You'll touch and caress me, excite me and arouse me, so that we both have the most beautiful, sexual, and satisfying time together.

One. Two. THREE!

Remember, of course, that for the best effect repeat the suggestions a couple of times before doing the count.

You might also want to be more explicit about what you want your partner to do:

I'm going to count to three in a moment. One the count of three you'll hunger to have my cock in your mouth. You'll open your eyes, go down on me and start sucking my cock. You'll hunger for me, need me in your mouth. And then, after a while I'll push you face-down onto the bed and fuck you from behind and you'll love it; it'll feel SO good!

One. Two. THREE!

Or for you ladies reading out there:

I'm going to count to three in a moment. At three you'll open your eyes and then go down between my legs and start licking and sucking my clitoris. You'll feel so good and it'll taste so beautiful to have my sex in your mouth. You'll love feeling me respond to your tongue... and then, when I tell you to, you'll stop licking me and you'll climb on top of me and start fucking me as hard as you can.

One. Two. THREE!

LESS RESPONSIVE, OR SLOWER, SEXUALLY? Hey! The book so far has been on how to heat up your sex life with hypnosis. Why cool it down? Hmmmm. Well, for one thing you can use hypnosis as a sort of "heat" regulator to help you both climax around the same time. If one of you is coming to the boil too fast it's nice to be able to turn their heat down for a while and then turn it back up later. This sort of control can be useful for guys who want to be able to last a bit longer. Keep in mind though, that hypnosis isn't a cure for sexual dysfunction and serious problems should always be referred to a doctor or specialist.

Here's a simple script that you can try out with your partner to slow them down:

On the count of three you will open your eyes and be ready to make love to me. You will open your eyes and you'll act like you're wide awake even though you will still be in this trance.

You'll be ready to make love and you'll enjoy touching and caressing me and being touched and caressed s me. You'll respond more slowly than usual, particularly once your penis is inside me. I want it to take a little longer than usual for you to come. I want you to be able to enjoy the feeling, savor the feeling of my vagina wrapped around your penis, to enjoy the feeling of movement and then come later if you can. You'll find that the feelings you'll have won't push you to orgasm as fast as you're used to.

One. Two. THREE!

Note that the script is not authoritative or demanding and just seeks an *improvement*. It is important that you don't use hypnosis to

put pressure on your partner to perform in any particular way. Look just for gradual change, and improvements in small steps.

DEBRIEFING. I spoke about debriefing in the chapter on hypnotizing your partner. It can be just as useful to have a debriefing after sex. Take the time to talk with your partner about how it worked for you, what worked and what didn't, how you think that it could be better and what you'd like to experiment with or explore in future.

Discuss. Never demand and never blame. Your partner is your friend and your teammate. Work together to make sex absolutely fucking[2] brilliant!

2. *There's that play on words again!*

Inhibitions

I'VE written this little chapter on inhibitions because I believe that often we're our own worst enemies when it comes to having a good time. There are zillions of things that you can do – and I don't just mean sexually – to have an absolutely brilliant time, but sometimes shyness or fear of embarrassment can get in the way of us actually pulling our fingers out and getting up and doing them.

It's also not just shyness or embarrassment that can stop us. Sometimes it's that we don't want to look like idiots, or we don't want others (including our partners) to think less of us or lose respect for us, and sometimes it can even be the voices of our parents or of society saying, "nice people don't do things like that!"

Inhibitions include:

1. Fear of losing respect,

2. Fear of looking like an idiot,

3. Shyness,

4. Fear of embarrassment,

5. Social or family conditioning; i.e., "nice people don't…"

If you've ever thought that there's something you'd like to try but were afraid of what someone else – even your partner – might think about it; or if something inside you – a little voice – said, "no, that's

just not right," even though the activity was completely safe, then you've been the victim of an inhibition.

WHERE INHIBITIONS COME FROM. As babies we don't have inhibitions; we learn them, and we learn them two ways. The first way is by example – i.e., from the way our parents behave and from what they tell us is the "right" way to behave, from school; from friends, from the way people behave out in the street, on TV and in the movies. The second way is the hard way – by experience – i.e., by being laughed at, by being made to look a fool, or by being hurt.

Inhibitions are, of course, a type of conditioning.

HOW TO OVERCOME INHIBITIONS. Hypnosis can help your partner overcome their inhibitions. It needs an effort from them, certainly, but for them to overcome inhibitions *you* need to help by creating a new environment, a safe and accepting environment where your partner can "let themselves go" without fear. This means encouraging and allowing them to express their thoughts and ideas *without pressure*. It means being open and accepting of whatever they say. Never laugh at them or put them down because of what they say or what they think.

Some people are turned on by really weird things and sometimes, I'll admit, my partners have suggested the strangest things to me... and I've laughed. But it's not the fact that you laugh that can cause damage and make your partner close themselves up. It's how you laugh and what you laugh at. If you find the idea of dressing up as Tarzan to make love funny, well so be it. But don't put your partner down for wanting it – I'm sure there are stranger ideas lurking in your mind.

What it's really about is good communication. You'll help your partner to open up and to learn to do things by being open yourself, and by accepting the weirdnesses that we're all completely capable of. Explore your own and your partner's weirdnesses; you'll discover an amazingly rich vein of kink and sexuality.

WHERE HYPNOSIS FITS IN. Now, having just given you my little pep talk about openness and communication, I want to show you

how you can use hypnosis, particularly post-hypnotic suggestion, in the inhibition department. It's very important to realize two things here. First, while hypnosis might relax them and help them open up to their own inner desires it isn't going to create a sexual animal where none was before. The best that hypnosis can do is unlock the cage. The sexual animal must already be in there.

Second, like always, you need to work *with* your partner in this. Discuss and plan what you are going to do beforehand so that both you and your partner have a common and well-understood goal.

LEARNING TO BE MORE OPEN AND ACCEPTING. When your partner is not so open or accepting as they would like to be – when they're prudish or have trouble accepting some of your strange ideas in the bedroom – this script can help them to be more tolerant and maybe less prudish:

> *There are many ideas, many ways of making love and many ways of exploring sex that the two of us will discover as we go on together. It's important that we keep our minds open to new ideas. It's important that we look at and maybe try the things that we find so that we both might find more excitement and sexual satisfaction with each other.*

> *Lots of the things that we'll come across will be things one or both of us have never tried before. I'd like us to be able to consider all these things for us, even if we don't ultimately end up trying all of them. I'd like us to be able to add things to our repertoire even though we might never have done them before.*

> *In future you'll find yourself more open and able to consider new techniques, positions, etc. You'll find yourself more enthusiastically considering the different things we discuss, rather than just dismissing them out of hand.*

> *When you hear a new idea that's not something you personally like, there's no need to condemn it completely or laugh at it. There are plenty of ideas and things that suit other people that don't*

suit you and that never will, but that doesn't mean they aren't valuable to the people who have them.

By criticising or putting down other people's ideas you are also putting down those people, and this is not a good way to encourage them to talk to you and be open with you.

In future you'll find it easier and easier to listen to other people's points of view without having an automatic "knee-jerk" reaction that it's bad. This will apply also when we're talking about sex: you'll find it easier to listen to my ideas and suggestions without automatically rejecting them.

At the same time you'll find yourself accepting and realizing that there are many ideas and activities out there that are interesting and exciting even though you've never thought to look at them or try them before. You'll find that you're able to look at and think about different ways of doing things, considering more easily whether they are suitable for you or for us.

As time goes on your horizons will expand and you'll find yourself becoming more tolerant and more accepting of, even embracing, new ideas.

LEARNING TO BE BRAVE. I think that it takes an act of courage to try doing something, or to try suggesting something, when you've been knocked down and hurt already because of it. This is the situation your partner encounters when they're thinking of doing something with you that's caused them to be embarrassed or mocked in the past. You might not even know that there is this stumbling block in their minds, but here's a script that will help them to get it out:

In the future you'll find it easier to talk to me about your own private thoughts and fantasies. Any fear or awkwardness that you have about talking will fade so that it'll become easier to discuss and maybe plan new and interesting activities.

Any bad experience you had in the past talking about or trying out your ideas and fantasies were just that: in the past. You don't need to have those times affect you now.

The effect that the bad times in your past had on you and on your ability to explore and experiment sexually can and will fade from now on. As time passes you'll be able to open up more; you'll be able to talk about and try new things more easily.

LEARNING TO RE-EVALUATE. When your partner is eager to try something and has trouble with guilt, or with feelings that it just "isn't right," it could be coming from the "nice people don't...." messages that they've been getting from their family and so on. Of course, sometimes things aren't right and aren't safe – like playing with chainsaws – and so the inhibitions should stay; but when you've both discussed and agreed that *whatever-it-is* is safe and desirable, the following script might help:

What we do together in private is between us. It doesn't matter what other people do, or what the rest of society does; what is important is that what we do is something that is good and satisfying for both of us.

In future your feelings of awkwardness or guilt about the safe and healthy things we do together will become less and less. The rational part of your mind can decide what is good for us and will be able to get rid of the feelings that stop you from enjoying those activities.

The inhibitions that you learned earlier in your life and which are now getting in the way of our enjoyment together have outlived their usefulness; it's time for them to go so that you can make up your mind yourself about what we do. The inhibitions will fade and leave you free to explore and be everything that you can be.

Fantasy

MANY people who are hypnotized are capable of having intense and compelling fantasies. These fantasies can be far more intense and involving than fantasies which they may explore or experience at other times. In this chapter I present a number of sexual fantasies which you can "give" to your hypnotized partner. After putting them in a trance you verbally create and then guide them through the fantasy. Your partner need not be naked, but don't be surprised if your partner *does* climax (i.e., orgasm) during the experience.

Before I continue, though, I want to give you a bit of a warning. When your partner responds well the fantasies can seem very real; therefore be very careful about giving them fantasies about things that might frighten or shock them. For example, some women fantasize about rape. This is OK when it's *their* fantasy; they know that it's a fantasy and it's under their control. Now, real rape is not a pleasant experience for a woman and can emotionally and sexually scar her for a very long time. A rape fantasy using hypnosis can be so real for your partner that it terrifies and does the same scarring as the real thing. Leave it alone.

Be also very careful of any fantasies that are scary or confronting in any way, like public nudity, sex with strangers, snakes, spiders, heights, frightening locations and so on.

I like to create just enough of a fantasy so that it has a basic shape and so that I know what's going on; then I let my partner's imagination fill in the details – like sights, sounds and smells. You'll see this in the upcoming scripts. If you are a bit of a storyteller you might like to try creating more elaborate scenes, for example:

You follow this naked beauty, your eyes transfixed by her narrow waist, broad hips and gently swaying backside, as she walks down the plain wooden hall and pushes open the door into her dimly-lit bedroom. You briefly glance around at the walls of the room, covered from ceiling to floor with deep scarlet silk wall hangings and, as you enter, your feet sink deep into the soft, warm thick rug laying on the bare floor between the door and her white-silk-hung four-poster king-size bed. Your first breath fills you with the scent of incense, which you realize is coming from the two burning sticks on the small table beside the bed that you are inexorably being drawn towards.

As a good sourcebook for sexual fantasies I very strongly recommend Nancy Friday's books. Nancy Friday became famous for *My Secret Garden* (published in 1973), one of the first serious books to explore female sexual fantasies. More than twenty years later she looked again at modern female fantasies in *Women On Top* and at male sexual fantasies in *Men In Love*. All three of these books are great places to find fantasies explained, categorized and ready for use.

Running a fantasy session with your partner is fairly straightforward. You hypnotize them and then use one of the scripts below, or one of your own making, to create the fantasy in your partner's mind. Tell them the fantasy just as if you were telling them a story. Give your partner plenty of time to build the images in their mind, and to feel and become involved in the fantasy themselves.

After the session be sure to debrief your partner and find out how it worked for them, and maybe what changes – like type of fantasy, pace or delivery – could be made.

If your partner has a tendency to fall asleep after making love, you might find that they also really fall asleep during the sexual fantasy. If they do fall asleep make sure that you're around when they wake up

because they may still partially remain in the trance and you may need to do a simple wake-up with them. It can be a good idea to do your first sexual fantasy with your partner in the evening when it won't matter if they nod off and when you have plenty of time.

At the end of each fantasy I like to let my partner "soak" for a bit before *recovering* them. This recovery is where you bring your partner back to reality from the fantasy world you created for them. Just waking your partner at the end of the fantasy can be a sudden jolt. It is much gentler to guide your partner back to reality while they are still in the trance, and then wake them up after that. Here's an example:

Now the fantasy is ending and you are back in our bedroom. You've been fantasizing while in a trance and now you're back home with me. You're no longer in the fantasy that I created for you; you're back in reality. Relax and go deeper into the trance.

This is nice and simple and focuses your partner's mind back on reality. This isn't part of the story that you tell your partner to create the fantasy, so use a different voice. I like to use a stronger and more imperative or authoritative voice when doing a recovery than when I'm telling the story. Sometimes the fantasy you can create is so pleasant that your partner will not want to leave it straight away. Using a strong voice lets you order them back to reality.

Because of the descriptive nature of the scripts many are gender-specific (i.e., they are written to "work" for one gender or the other). Just before each script I give a quick summary and explain the gender roles, if any, used. Please feel free to adapt the scripts to suit you or your partner.

JOINING THE MILE-HIGH CLUB. Quick summary: your partner is in an airplane with you. During the in-flight movie you both sneak back to the toilets for a quickie. This script is written for a hypnotized male partner with the female partner (the hypnotist) guiding the fantasy.

Imagine now that we're in an airplane. We're on our way to London for a holiday. They've just finished serving dinner and

now the in-flight movie is on. You've already seen the movie and you're bored.

You look over at me and you have the idea to make love with me while the movie's on.

You reach over and start stroking my thigh. When I look over to you you smile and lean over to me. You tell me to meet you at the back of the plane. Then you undo your seat-belt, stand up and walk down the aisle.

At the back of the plane you stop and look out one of the windows there. You can see the sky getting dark and the clouds way down below us.

After a minute or so you feel my hand on your shoulder. You turn round and guide me into one of the toilets. You check to make sure that no one notices. No one does.

As the door closes you turn the lock and the little light comes on. Without saying a word you press yourself up against me, wrap your arms around me and give me a long and wet, sexy kiss. You can feel your penis getting hard in your pants, pressing against me. You are getting very horny.

As your penis gets harder you reach down and start rubbing and squeezing my backside. You can feel my arms around you as I pull myself hard against you. You feel my body rubbing against yours as the plane gently rocks and you get even hornier.

Suddenly you feel a rush of sexual hunger and you reach down and start lifting up my T-shirt. As you do you rub your hands up my back. You feel my breasts fall out and you reach up to stroke them briefly before removing your own shirt.

As your shirt comes off I rub my hands through the hair on your chest and I squeeze your nipples gently. You reach over and stroke my breasts again for a moment before pulling down my tracksuit pants and panties both at the same time.

One of my hands is still rubbing your chest. The other is between your legs, rubbing the bulge in your pants. You are feeling very, very horny now.

You slip one hand between my thighs and you feel that I'm very wet. You can feel the sexual tension building between us and you know that I want to feel you inside me.

Although there's not much space you manage to help me to turn around and to lean over the closed toilet. As I bend over you pull your pants down and start to slide your penis into me. I feel so warm and wet to you. My vagina feels so warm and wet and tight.

As you slide into me the gentle rocking of the plane helps you develop your rhythm. You find it easy to thrust into me because the rocking of the plane is helping you to push.

My vagina is so tight and hot. You keep thrusting, holding onto my hips and pushing; pushing harder and harder.

Even though there is the rushing and the roaring of the airplane's engines you can hear me starting to moan with pleasure. You know I am loving what you are doing. You can feel yourself more and more aroused all the time. You know that it won't be much longer before you come.

The rocking of the plane is helping you push into me. It's easy to push deep into my hot, wet vagina.

Suddenly you feel a rippling in my vagina, a squeezing sensation, and you know that I am coming. You hear me trying to stifle a cry. The feeling of me coming brings you to orgasm.

You grip my hips even harder and push yourself hard into me. You drive your penis into me and feel yourself come deep inside me.

As you finish coming you feel a deep wave of relaxation wash over you. You feel a little drowsy and relaxed.

After a few moments you pull your penis out of me. I turn around and look up at you, smiling. You lean forward and kiss me lightly, gently, on the lips.

We both grab some toilet paper and clean ourselves up. You unlock the door and go out, back to your seat. I wait for a moment and the follow you.

As I get back to my seat you are feeling happily drowsy and content. You cover yourself with the blanket and let yourself fall asleep.

(Pause to let the final image sink in)

Now we're back in our bedroom. You've been fantasizing while in a trance and now you're back home with me. We're no longer in the airplane, we're back in reality. Relax and go deeper into the trance now.

MAKING LOVE ON A TROPICAL BEACH. You (male hypnotist) and your partner (female subject) are walking along a tropical beach at sunset. You stop and make love on the beach.

It's late in the day on the second day of our vacation on this beautiful tropical island. It's been a lovely warm day and now we're taking a stroll down the beach as the sun goes down.

You can feel a pleasant cool breeze blowing along the beach. There's no one around now; all the people that were here during the day have gone back to their hotels for dinner. We're alone on the sand.

We're walking along with our arms around each other. We're walking slowly down towards the quiet and secluded end of the beach.

You're starting to feel pleasantly warm and sensual now. You can feel my warm arm around you and the feeling of my body pressed up against yours is starting to turn you on. You are starting to feel nice and sexy and you want to make love.

You look around and you can see that there's no one on this section of the beach except for us. It's all quiet except for the sounds of the ocean and the breeze in the trees.

You stop me and gently swing me around so that we're face to face. You kiss me. It's a long, sensual kiss, and as you kiss me you let your hands run down my body.

You're starting to feel very sexy now. You feel me respond to your kiss. I put my arms around you and pull you tight to me.

You can feel me reach my hands up the back of your shirt and undo your bra, then my hands move around to the front and start caressing your breasts. My hands feel strong and smooth and warm. You feel your nipples sticking out and pushing against my fingers.

I pull your shirt over your head and drop it on the sand. The you take your bra off and drop it on the shirt. You undo your dress and step out of it. At the same time you see me undressing. You see the bulge in my pants and then you see my penis strongly spring out of my pants as I pull them down.

You come back to me wearing only your panties. You put your arms around me and feel my naked body against yours. You can feel my hard penis pressing up against your skin.

Your vagina is wet and you feel the wetness spreading into your panties. You pull your panties down and, as you bend over, you lightly lick the end of my penis. You feel me quiver with excitement. You stand up and gently hold and caress my penis with one hand. At the same time you guide my hand between your legs and tell me to rub you.

You feel my hand between your thighs. A finger pushes into your vagina and you move your legs apart a little.

You feel the warm sand between your toes as you crouch down and sit on your shirt. You can feel the sand, still warm from the sun, underneath you. You pull me down with you and feel me leaning over you.

I lean down and kiss your nipples. You lift up your knees and move them apart. As you do I position myself over you and the

guide my penis into you. You can feel the warm sand underneath your back and between your fingers as I push my penis into you and start thrusting.

You can still hear the waves on the beach and feel the warm sand underneath you as I move in and out of you. From time to time I lean forward and kiss you. You feel the brush of my lips against yours.

As my penis moves inside you you can feel a beautiful sexual tension building up inside you. You feel the muscles in your vagina starting to twitch and you start to move, trying to change position to get the best feeling of what I'm doing.

The tension is building up more and more. Soon you will feel a beautiful release.

Suddenly you hear me moan and push hard into you. You realize that while you were thinking of your own feelings I came inside you. You feel very happy and pleased that I just came and it helps you to climax.

You feel your body rock as a warm, relaxing wave of pleasure spreads through you. You still feel my penis push inside you, slower now that I've come, and you feel the warmth and the gentle waves coming from that movement.

You relax and let yourself go. You enjoy the feelings and relax.

(Pause to let the final image sink in)

Now we are back home. We are no longer on vacation and we're no longer on the beach. We're back at home in our bedroom. You're in a trance and you're coming back to reality. You're no longer on the tropical island. Just relax now and go deeper into the trance.

PEEPING TOM. Your partner (no gender specified) fantasizes about making love with you and then, part-way through, realizes that there is a peeping tom watching. This doesn't cause your partner to stop. In fact, it makes them even hornier.

I want you to imagine now that we're making love. We're lying in bed together and we're both naked.

I am touching and caressing you. My hands feel very warm and sensual and I'm touching you just the way you need to be touched. You're feeling horny as I caress you and rub you.

Imagine that I'm lying beside you. You can feel my warm body next to yours and you can feel my hands exploring all the sensitive and sexy parts of your body.

The more I touch you the hornier you become.

Now, as you change position on the bed you glance out the window. You see the shadow of someone looking in – it is a peeping tom. You can't see their face to recognize who it is but you know that someone is there.

This doesn't frighten you or worry you. In fact, it seems to make you feel even sexier and hornier. You start to move around more on the bed as I touch you. You know that we're being watched and it adds extra spice to what you're feeling.

(Pause)

Now we start making love. You feel my body moving against yours. The thought of the person watching us keeps popping up in your mind. It makes you feel even sexier and makes you want me even more.

(Pause)

Every now and then you glance over at the window. Each time you see that the shadow is still there. And each time you see the shadow you feel more turned on.

(Pause)

Now you feel an orgasm building up. You feel my body pushing against yours and feel that beautiful sexual tension building up inside you.

It's getting stronger and stronger.

(Pause)

Now you're about to come. It's closer... You're coming now. It's beautiful and strong.

(Pause)

Now you're lying beside me. Your body is pressed up against mine and we have our arms around each other. You feel very warm and relaxed after our love-making. You look over to the window again and see the shadow of the peeping tom is now gone.

You close your eyes and snuggle up closer to me.

(Long pause to let your partner enjoy the snuggle)

OK. The fantasy is over now. You're back in reality with me. Relax and sink down deeper into the trance.

MAKING LOVE IN A DEPARTMENT STORE. **Your partner (no gender specified) fantasizes about making love with you in a bedroom display in a department store window. No one seems to notice you.**

I want you to imagine that we're walking through a large department store. We're on the ground floor and we're just wandering around the department store together. I have my arm around you and you can feel the warmth of my body against yours.

As we walk along you start to feel sexy and horny. The warmth of my body against yours as we walk along together is making you feel really horny.

Now, we're still walking around the department store and we're near one of the window displays. There's a large, king-size bed in the window. You can see the large, soft bed, and you can see the window and the people walking past outside.

You're feeling so sexy now that you grab me and drag me over to the bed. You don't want to wait any more. You need to make love and you can't wait.

You quickly strip off your clothes and start undressing me. As you do you keep looking around to see if anyone is watching, but no one is looking. Even the people walking past outside don't seem to notice what's going on in the window.

We're naked now, and we're both lying on the bed. We're touching and caressing each other and you can feel that I'm very horny too. Every now and then you look around to see who's watching and although there are people nearby in the store and there are people walking past the window no one pays any attention to us.

You're feeling so very horny now. The idea that we're making love in such a public place is really turning you on.

(Pause)

We're making love. You can feel it. You feel more alive and sexy than you've felt before. Your body is alive and you are feeling more beautiful than ever before. You just lose yourself in our love-making as the sensations overwhelm you. Just let yourself go completely.

You're getting close to coming. You feel that sexual tension building up inside you and you're getting closer and closer to coming. You're going to come in a moment.

(Pause)

You can tell that I'm getting close to coming, too. We're both going to come now. You feel your orgasm starting and you feel me come as well. We're both coming at the same time. You feel the waves of pleasure flowing over you.

(Pause)

Now it's over. We've finished making love and we're lying next to each other relaxing.

(Pause)

We're getting up now and getting dressed again. You look at the bed and you see it's a total mess. We're walking away from the

bed now and you're smiling to yourself. You're pleased and thrilled that we've just made love in such a public place.

(Pause)

Now we're back in our bedroom now. You've been fantasizing while in a trance and now you're back home with me. We're no longer in the department store, we're back in reality. Relax and go deeper into the trance now.

SURGEON MAKES LOVE TO PATIENT. Your male partner is a surgeon in a hospital. Doing his rounds of patients awaiting surgery he enters the private room of an attractive young woman who proves very open to his attentions.

You are now a doctor. I want you to imagine that you're a doctor, a surgeon, in a hospital. You have your stethoscope around your neck and you're doing your rounds of patients who are due for surgery.

You're walking down the corridor of the hospital. There are a few nurses and other doctors in the corridor and you nod and smile at them as you walk towards the private room of your next patient.

You open the door of your patient's room. She's an attractive young blonde woman in for minor surgery to remove an infected splinter from her backside.

The room she's in is nice and bright. Your patient is propped up in bed reading a magazine. She is wearing loose-fitting flannelette pajamas. As you enter the room she looks up at you and smiles very warmly. You can't help noticing her beauty and the sparkle in her eyes.

As you cross over to her bed she puts down her magazine and looks up at you expectantly. You reach out for her arm and start to take her pulse. You feel the warmth and smoothness of the skin on her wrist as you do.

She sits up in the bed and leans towards you a little. As you look down at her you see that her pajama top has fallen forward a

little and that you can see her breasts and nipples. Her nipples are large and brown and, as you gaze at them, you see them start to crinkle up and become erect.

You drag your attention back to your watch as you finish taking her pulse. Her pulse is normal.

You then ask her to undo the top buttons of her pajama top so that you can place your stethoscope on her chest and listen to her heart.

She undoes more buttons than necessary and, as she opens up her top, one of her breasts gently falls out. You see that her nipple is fully erect.

As you place your stethoscope on her chest you realize that she is smiling at you. It is a warm friendly smile. She does not appear at all embarrassed that one of her breasts is exposed. In fact, her smile seems to indicate that she is interested.

You're starting to feel a little horny now and you reach up with your free hand and gently grasp her nipple and start rolling it between your fingers. Her eyes close and she starts to make a sound almost like purring.

After a few moments you stop and tell her to roll over and pull down her pajamas. She smiles as she rolls over and pulls her pajama bottoms down. As she rolls over you see the inflamed red spot on one cheek where you will be operating. As you touch it she twitches and moans a little.

You gently touch the red area and her moans become louder. With your other hand you start caressing her other cheek. She moves a little to make herself more comfortable.

As you stroke her backside you start feeling hornier. You feel an erection growing in your pants. You feel your penis pushing harder and harder against the front of your pants.

You continue stroking your patient's backside and then start slipping your fingers between her cheeks. Her moans become more steady and she starts to push her backside up in the air a little, pushing it against your hands. At the same time she moves her legs apart a little.

You reach between her thighs and slip one finger into her vagina. She is very warm and wet. She lifts her backside even more and then pushes herself down onto your finger. It slides even deeper inside her.

You continue to touch and caress her and explore her vagina with your finger. She continues to writhe and moan and push herself against your hand.

After a few minutes of this you can't take it any more. You are feeling desperately horny. You quickly undo your pants and pull them down. Your big hard penis springs out and you know where you need to put it.

You quickly climb up on the bed and grab your patient's hips. Your penis slides easily into her and, as it does, she moans deeply and lifts her backside up even higher to meet you.

Her vagina feels very warm and tight. It seems to wrap itself around and grip your penis.

As you thrust into her you feel the tension quickly build up inside you. After only a few moments you come inside her. You feel the rush inside you and you grip her hips even more tightly, pushing hard inside her.

As you finish coming you stop for a moment and just enjoy the feeling of her beautiful vagina.

(Pause)

Now you pull your penis out of her and climb off the bed. Your penis is becoming limp again as you grab a tissue from the bedside table and wipe yourself clean.

Your patient has gently collapsed onto the bed and you see the shine of her sweat. She is still breathing heavily as you do your pants back up.

You move to the door and, as you swing the door open, you look back and smile to yourself. Then you leave and continue on your rounds.

Now we're back in our bedroom. You've been fantasizing while in a trance and now you're back home with me. We're no longer in the hospital, we're back in reality. Relax and go deeper into the trance now.

PATIENT MAKES LOVE TO SURGEON. This is the previous fantasy seen from "the other side." Your female partner is a patient – in for minor surgery – in a private hospital room. The doctor enters and, during the course of an examination, becomes intimate and ends up making love to your partner. Your partner meekly, and then hungrily, submits.

I want you to imagine now that you're lying in a hospital bed in a room in a hospital. You're in a private room and the door is closed. You just arrived this morning for an operation to remove an infected splinter from your backside.

You're in a nice and airy room. The curtains are open, it's a sunny day and the sky is clear. You are dressed in a loose smock and you are expecting your doctor to come around soon to examine you.

You're lying in your bed waiting for the doctor. You're reading a book while you wait.

The door opens and your doctor comes in. He is an attractive man who moves and talks to you with an air of authority and certainty.

When he reaches your bed he picks up your hand and measures your pulse. You notice his eyes wandering over to your smock and you realize that the top two buttons of your smock are open and that he can probably see your breasts and nipples. You feel too

awkward to do anything about it so you just wait to see what he will do.

He finishes with your wrist and places it back on the bed. He tells you to open your smock so that he can listen to your heart. You undo a couple more buttons on your smock. He reaches over and, with his free hand, adjusts the smock as he places the stethoscope just above and between your breasts. As he listens he moves his free hand inside your smock and cups one of your breasts in his hand. You're shocked, but you still don't know how to react to him. You realize, though, that erotic feelings are stirring in you. You start to blush in embarrassment.

He finishes listening to your heart and removes his hand from inside your smock. He orders you to roll over and uncover your backside. You turn over without saying anything, bury your head in the pillow and pull up the smock. You aren't wearing any panties.

You feel him touching your backside, examining where the splinter entered. His hands are warm as they move over your skin.

Suddenly you feel one hand move down to your thigh and then slip between your legs. He starts to rub you lightly. At the same time his other hand is firmly on your backside, pushing down and discouraging you from trying to turn over. You start to feel a hot flush as your body responds to his touch. You feel helpless to do anything except let him continue.

As his one hand rubs between your legs his other hand begins to caress your backside. You feel his strong hand rubbing your backside. A few moments later his fingers slip between your cheeks and you feel him rubbing your anus. It feels incredibly beautiful.

Without thinking about it your legs start to spread apart and you begin to push your backside up in the air, opening yourself to him. You're shocked with yourself but know that you can't stop it happening.

You feel him push his fingers inside your vagina. You realize that you are soaking wet. His fingers feel so good inside you.

Suddenly he withdraws his hands and you feel annoyed – it was feeling so good! Then you hear him undo his pants and something inside you smiles – you are going to be penetrated!

The bed moves as he climbs on and you can feel his hands grip your hips. As he slides his penis into you you push back towards him to get it as deeply inside you as possible.

He starts to thrust and you feel his hardness inside you. The bed sways with each thrust and you enjoy each one immensely.

(Pause)

After a few minutes he suddenly grips your hips very tightly. Then he lies back and relaxes. He has come inside you. After a moment he pulls his penis out and climbs off the bed. As he does you sink down flat on the bed. You hear him do up his pants.

He pulls your smock down over your naked backside and you hear him walk to the door. As the door closes you hear him say that he will be back to check on you later.

We're back in our bedroom now. You've been fantasizing while in a trance and now you're back home with me. We're no longer in the hospital, we're back in reality. Relax and go deeper into the trance now.

PICKED UP AT THE BEACH. Your partner (female) is picked up by a handsome guy at the beach. He takes her back to his beach-side apartment and they make love.

You're lying on the beach on your own. It is a hot sunny day and you're lying on your back, relaxing, letting your body soak up the sun. The sand underneath your towel feels nice and warm.

Now you roll over and undo your top so you can get an even tan across your back. You lean your chin on your hands and look around at the other people there.

You're just about to close your eyes and relax when you see a really gorgeous guy walking down the beach in your direction. He's carrying his towel and is obviously looking for somewhere to lie down.

You keep staring at his beautiful, hard, muscular body as he gets closer. You're still staring when he looks in your direction. You don't turn away but keep looking at him. You smile.

He heads in your direction and, when he gets near, asks if he can lay out his towel near you. You, of course, don't have any objection. You can't believe your luck as this incredibly handsome guy puts down his towel and sits.

He introduces himself and you tell him your name. You make small talk about the weather and the surf for a few moments.

Then you decide to put some suntan lotion on your back. You sit up, holding your bikini top in place with one arm. You manage to get some lotion on your other hand and reach around to rub it on. The guy is watching you with a little smile on his face. As you fumble with the lotion he asks if he can help. You gratefully accept.

He starts to spread the lotion on your back. His hands feel firm and strong on you and you close your eyes and savour the feeling. It is very sensual.

(Pause)

He finishes rubbing the lotion on and you start to put the cap back on the lotion bottle. As you do you lose your bikini top and it falls down onto your towel.

As you quickly reach for it you realize the guy is admiring your breasts. Strangely, you don't feel embarrassed. Instead you feel a little excited. As you pull the bikini top into place he looks up from your breasts and smiles.

You smile seductively back and you can't help glancing at the bulge in his trunks. It seems like the bulge is getting bigger. You smile at the reaction you've caused.

You lay down again and continue chatting with him. It turns out that he lives quite nearby and comes down to the beach for a few minutes every now and then. He says he doesn't stay out long because his skin is very sensitive. This comment causes you to glance at his body and you think how nice it would be to rub and stroke that skin.

After a while you're starting to feel very comfortable with him. He is an attractive and funny man. You are feeling sexually attracted to him.

Suddenly he says he has to get out of the sun and is going home. You feel very disappointed. He realizes you're disappointed and invites you back to his apartment for coffee. He says it isn't far.

You realize that something is happening between you both and you feel a warm rush as you accept.

You do up your bikini top, gather up your things and walk off with him. You don't bother putting on your street clothes, you just walk up the beach with him.

It turns out that his apartment is right on the beach. As you walk up to it you suddenly feel that he has put his arm around you. It feels so warm and strong. You lean against him and put your arm around his waist. He smiles at you and you feel a sexual tension building up between you. You're starting to feel very horny and you wonder if there's a damp spot forming in your bikini bottom.

As you reach the door to his apartment he gently turns you towards him and runs his hand down your side, resting it then on your hip. He pulls you towards him. You look up at him and he presses his lips hard against yours. His hand is on your backside now and you feel a thrill run through your body.

He pushes his key into the door without taking his arm away from you. As the door opens he releases his grip and guides you in. You are already undoing your bikini top and you let it fall to the floor.

You reach out for him, pull him towards you and wrap your arms around him as your lips search for his nipples. You look down and see that his trunks can hardly contain his erection. You reach into them and feel his hardness. You pull them down and feel the anticipation of having him inside you. Already you feel so wet. You can hardly wait.

You're feeling very horny as you run your hands up his body. You feel one of his hands reach down and gently push between your thighs and start rubbing. Your legs automatically move apart and you feel him slip one finger inside your bikini bottom and slip it inside you. It feels so good.

He guides you into the small dining room and over to the couch. He sits down and you see his beautiful penis sticking straight up in the air. It looks so big. You pull down your bikini bottom and straddle his legs. You don't let him into you just yet, though.

You reach down with one hand and stroke his shaft as you lean forward and press your lips against his and push your tongue into his mouth. You feel his hands reach up and cup and caress your breasts. Your nipples feel hard against the palms of his hands.

(Pause)

After a few moments you slide your body forward and then lower yourself onto his penis. You guide it in with your hand and feel it slip easily and deeply inside you.

You start to ride him, moving up and down on his shaft, feeling it move inside you, pushing inside you. It feels so big and hard there.

Your guy is leaning back on the couch now. His eyes are closed but he still has his hands on your breasts, moving them and caressing your breasts. Occasionally he lightly pinches your nipples and you feel a little thrill run though you as he does.

You tighten your vagina muscles around his penis and hear him lightly moan in response. His hands move down to your hips and he grips you tightly.

You feel the muscles moving in your legs and feel his beautiful penis sliding inside you. It feels so good and you feel hornier than you have ever done before. You feel an orgasm building up inside you. The tension is getting higher. You lean forward and hold onto his shoulders as you move.

The more you move up and down the better it feels. You feel the orgasm getting closer. You slow down a little to let the tension last a little longer. You savor the feeling of that big, hard penis inside you.

Suddenly the guy pushes his pelvis up, thrusting his penis deeper inside you. You realize that he is coming and the push of his penis so deep inside you makes you come too. You grip his shoulders even tighter and push down on him. You want him as deep inside you as possible.

You shake a little as you come. You feel the muscles in your thighs and abdomen contracting strongly and uncontrollably. The tension slowly winds down and you find yourself leaning forward onto the guy's chest. He puts his hand around your lower back and you both relax together.

After a few minutes you get up and feel his cum starting to run down your leg. You find the bathroom and clean yourself up. When you come out, feeling the pleasant afterglow of a great orgasm, you find the guy lightly snoring, still in the same position on the couch.

You get your bikini, put it back on, and gather up your things. You open the door and look back at the couch. He is still snoring. You blow him a kiss and then pull the door closed behind you as you leave.

(Pause to let the final image sink in)

Ok. You are no longer at the apartment near the beach. You are back with me in our bedroom. The fantasy is over now. Relax. Relax and go deeper into the trance. You are back with me. The

episode with the guy at the beach is over. You are back in our bedroom with me. Relax.

MEETING AN ENTHUSIASTIC LADY IN A BAR. Your male partner fantasizes about meeting a voluptuous and enthusiastic woman in a bar. They go back to her place and make love.

It's the end of the day and you've had a hard day at the office. On the way home you decide to stop in at a bar.

As you enter you see that the bar is about half-full. The air is a little smoky and a fan in the corner is moving the air around. Some of the customers are playing pool at one of the tables and the rest are gathered in small groups around the tables.

You go over to the counter and sit down. The barman walks down from where he has been sitting reading his newspaper. You order a beer. Once the barman has given you your beer he goes back to the end of the bar and sits down with his paper again.

You're feeling a little restless as you drink your beer. You find yourself reading the labels of the bottles behind the counter.

You're halfway through your beer when a woman sits down next to you. As the barman comes up to take her order you look her up and down.

She's got light brown hair hanging down to her shoulders, brown eyes and a face that reminds you of your favorite model. Her tailored business suit, now that she is sitting down, shows you that there is a nicely curved body under it.

She loosens the top two buttons of her blouse as the barman gets her her drink – a scotch. As she pays she has to turn slightly towards you and you can see that she is looking a little worse for the weather. You figure that she has had a hard day at the office too.

You return to your drink and then, after a couple more mouthfuls, you decide to talk to her.

She is enthusiastic and responsive and, after you've both complained about how tough the day was, you realize that she is starting to perk up. She turns towards you and you realize that she is really an attractive woman.

You start feeling quite comfortable talking to her. After a few minutes you see that she's focusing all her attention on you, even leaning forward towards you as she makes a point. More and more often she smiles warmly at you.

She places one hand on your thigh and it just seems natural. You suggest that you both go and sit at a table. She agrees. You order fresh drinks for you both and then sit down next to her at a table in the corner.

You keep chatting and she places her hand on your thigh again. You put your arm around her shoulders and she looks up at you and smiles.

A few minutes later you both finish your drinks and she leads you out of the bar and around the corner to the apartment building where she lives.

She opens the door to her apartment and leads you in. Without hesitation she leads you into her bedroom, pulls back the sheet and then removes her jacket and the blouse underneath. She's wearing a sexy lace bra and you can see the shape of her nipples and that they are erect.

You feel your penis become erect as you watch; and then she is in front of you, loosening and taking off your tie, then your shirt, and then she undoes your belt.

Your penis is very hard now. She is crouched down on her knees in front of you, undoing your pants and pulling them down. You underpants are next, and as she pulls them down your penis springs out. She pauses a moment and gently stokes your penis with one hand and cups your testicles with the other. Her hands feel so warm and smooth – you feel your penis becoming even harder, straining.

She undoes your shoelaces and helps you to remove your shoes and to step out of your underpants and pants. Now you're completely naked.

As she stands up she strokes your penis again and you can't help moaning with pleasure. You reach around behind her and fumble with her bra, trying to open it. Finally it opens and, as you pull her bra forward, her breasts gently fall out.

You lean forward and kiss one of her nipples. You feel how erect it is, pushing against your lips.

You crouch down and undo her skirt and slide it down her legs. Then you pull down her panties and as she steps out of them you slide her high heels off. Now she is naked with you.

You slide your hands up her legs and feel how beautiful and warm and wet she is. As you stroke the lips of her vagina she moans quietly and arches herself back a little.

You stand up and guide her over to the bed. As she lies down, she lifts up her knees and moves her legs apart. She looks up at you invitingly and smiles. Her deep brown eyes are shining.

You move over on top of her and feel her hand reaching down and guiding you in. Your penis easily enters her. She is very warm – hot, even. Her vagina feels like it is wrapped around you. You start to thrust.

After a few moments you feel the muscles in her vagina starting to squeeze you. She's doing it to help you come.

You can feel the sexual tension building up in your body and you know you're going to come soon.

The tension is stronger and stronger. You're getting closer and closer to coming.

You come now. You feel yourself coming inside her. You push yourself deeper into her as you come. It feels so good. She smiles up at you.

Now you roll off her and lie beside her. Relax now.

(Pause to let the final image sink in)

Ok. Now you are no longer with the stranger you met in the bar. You are back here with me in our bedroom. Relax and go deeper into the trance. You're no longer with the woman you met in the bar. You're back in your own bed with me.

Sex and Post-Hypnotic Suggestion

POST-HYPNOTIC suggestion can be both useful and fun when combined with sex. One of the things I am going to talk about in this chapter is how to use PHS to control – to some degree – how quickly or how slowly your partner responds sexually. Now I want to remind you that this is *not* intended as a form of therapy for someone with sexual problems, including potency difficulties or premature ejaculation. Any sexual problems which are causing actual difficulties in your relationship should be dealt with by a professional therapist.

INSTANT AROUSAL. It can be, er, "diverting" to make your partner horny on a signal. If you are sadistically inclined you can trigger your partner somewhere in public like the local supermarket, just to see them suffer a little bit, or you can trigger them while you are sitting together having dinner at home (make sure that you can reheat the food!).

I'm going to show you two ways of doing this. The first is by a direct post-hypnotic suggestion, and the second is by using PHS to associate strong sexual feelings with a public part of your partner's body which you can then use to trigger them. You'll see what I mean shortly.

From now on whenever I say to you the phrase, "You look sexy in that outfit," you'll immediately start feeling very sexy and horny. It won't matter what you're doing at the time or where we both are; when you hear me say that phrase you'll immediately start feeling very hot and horny, and very hungry for sex.

As well, when I say to you the phrase, "No more horny," any horniness or sexual hungriness caused by me having said, "You look sexy in that outfit," will immediately and instantly disappear.

So when I say, "You look sexy in that outfit," you'll become very horny, and when I then say, "No more horny," that horniness will disappear.

How effective this post-hypnotic suggestion is will depend – as I have often mentioned in this book – on how deeply hypnotized your partner is when you give it, how strongly you give it, and on how sexual they are in the first place.

Arousal by Association. What I'm going to do here is show you a way that you can associate sexual feelings with your partner's earlobe. You can then use their earlobe to trigger sexual feelings in them. I'm sure that once I explain it you'll see how it works and that you'll be able to adapt this any way you like.

What you need to do is hypnotize your partner and have them naked, lying face up somewhere comfortable where you can sit next to them both within range of their, er, *sensitive* bits – i.e., their typical erogenous zones – and within range of one of their earlobes.

I am going to start touching you and stroking you sexually now and as I do you'll become very horny.

(Start touching and caressing your partner – maybe their breasts, pussy, penis, testicles, as appropriate.)

I want you to enjoy the way I am touching you now. I want you to feel my warm hand(s) stroking you and I want you to start

feeling very sexy. I want you to think only of the beautiful feelings that you are having now. I want you to respond so strongly to what I'm doing.

(Work at it now and, once your partner shows obvious signs that your ministrations are working, move on to the following:)

Now I'm going to touch your ear as well. In future when I touch and play with your ear the way I'm going to now, you'll become just as horny and you'll feel just as sexy as you do now.

(Start stroking your partner's earlobe while still touching their erogenous zones)

I want you to enjoy the way I touch your ear just as much as the way I am touching you with my other hand. I want to you find when I touch your ear that you become just as horny and just as aroused as when I touch your breasts/penis/etc.

Feel the way I'm stroking your ear now. It's just as warm and exciting as the way I'm touching you with my other hand. I want you feel the same feelings both now and any time in the future that I stroke your ear. It won't matter where we are or what we're doing in future – when I stroke your ear the way I'm doing now you'll become just as horny as if I were stroking your breasts/ pussy/penis/etc.

INSTANT NON-AROUSAL. If you are masochistically inclined you might want to be able to turn your partner *off* sexually. This isn't the sort of thing that I would normally go and do because, dammit!, I like hot ladies and I ain't gonna do anything to make them less hot!

However, once or twice it can be interesting to see how effective post-hypnotic suggestion can be like this:

Whenever I say the phrase, "Bucket of water," to you from now on any sexual feelings, any horniness or sexual hunger that you might be feeling will completely disappear. At the moment I say the phrase, "bucket of water," it will be like all your sexual feelings are temporarily pushed aside.

INCREASED SEXUAL RESPONSIVENESS. PHS can be used to increase your partner's sexual responsiveness and help them be more focused on their feelings and "the action" during sex. This can help your partner to get more pleasure and satisfaction out of sex. How well this works will, as always, vary according to depth of trance and so on, and also on how much, er, sex there actually is left to squeeze out of out of your partner. "Your mileage may vary."

In future, each time you make love you'll find that your body will become more sensitive and your erogenous zones more responsive. You'll find yourself better able to focus and become involved in what we are doing, and the sexual feelings and excitement will flow that much more freely in you.

You'll enjoy exploring both your sexual feelings and mine and you'll particularly enjoy our foreplay and the way it helps build up into beautiful, exciting and satisfying sex.

Combined with the extra responsiveness you'll also find that you'll be able to last longer. The sexual tension will build in such a way that you're able to continue longer each time.

Increased sexual responsiveness can, of course, lead to your partner climaxing more quickly than you both would like. The last paragraph in the above post-hypnotic suggestion attempts to deal with this. You might also like to try something like:

When we make love you'll find yourself focusing more and more on the sensuality – on the touching and caressing aspects of our love-making – than on the actual mechanics and the orgasms. You'll look forward to the way my body responds to your touch and you'll enjoy and savor the way my hands and body feel when they are pressed up against you.

You'll continue to enjoy the orgasms too, but your focus will move more towards enjoying the touch, the sensations, the romance and the togetherness.

POST-HYPNOTIC SUGGESTION TO BE MORE RESPONSIVE SEXUALLY. If your partner would like the effects of hypnotic sex to linger and be-

come part of your non-hypnotic sexual activities, then post-hypnotic suggestion is something that you should try. The following post-hypnotic suggestion can help your partner focus more and be more responsive during sex at any time.

In future when we make love you will find yourself better able to focus on what we are doing. Any problems or worries that you might have will less and less distract you from your feelings and what we are doing together.

You'll also find that you become able to respond more, that your body will feel more alive and that you'll be generally more sensitive to my stroking and caressing.

It'll become easier and more natural for you to respond sexually with me, and for you to have a deeply satisfying sexual experience with me. You'll be able to talk more easily with me, to discuss and suggest things that you'd like to do or try. You'll also find yourself feeling more comfortable with your sexual feelings and desires, and you'll be more comfortable exploring sex with me.

Repeat twice daily, and if there's no change get back to me... What? Er, sorry! What I meant to say was that you should repeat this post-hypnotic suggestion from time to time to help it keep its effectiveness.

Post-Hypnotic Suggestion to Be Less Responsive Sexually. If you and your partner would like love-making to proceed at maybe a more leisurely pace in general, you could try this post-hypnotic suggestion:

In future our love-making will proceed more slowly. You'll find that it becomes easier and more natural to move along slowly, for us to take our time, to let the foreplay just simply stretch out..

You'll still respond just as strongly – if not more – to me, it'll just become more pleasurable and easier to let your arousal grow slowly. You'll enjoy the build-up, the touching and the caressing and the hugging.

You'll be able to find a deeper sense of pleasure and a deeper feeling of satisfaction by letting the sexual tension build up between us for longer before release, before coming.

Each time it'll become easier and simpler to control and guide the action to give us both more time to savor and finally orgasm from the sensations we give each other.

Masturbation

MASTURBATION isn't always done alone. While it might be the case with some singles that their hands are their best friends, masturbation can also form a healthy part of a satisfying sexual *partnership*. In a partnership, solo masturbation can be a response to different levels of sex drive – i.e., one partner wants or needs sexual release more often than the other – or as a result of unfortunate circumstance – e.g., one partner starts feeling horny while the other is busy or tired. Masturbation with your partner – where one or the other, or both, of you touches or rubs the other without necessarily getting off themselves – can also be a way of handling those times when intercourse is not possible or desirable – e.g., for medical reasons, your partner is having her period, and so on – and can also be great way to learn how to push your partner's sex buttons.

In this chapter I want to talk about using hypnosis two ways:

1. Making your partner's solo masturbation sessions more intense and satisfying through post-hypnotic suggestions,

2. Joint sessions, where you watch and participate when your partner masturbates.

Fantasies are an important part of many people's masturbation. Talk to your partner about their fantasies beforehand and discuss with

them ways they can be incorporated into the scenes and scripts that you give them.

I have deliberately avoided talking about orgasms in the scripts below. There are people who don't come – mainly women – who still find masturbation and love-making extremely beautiful and satisfying. By mentioning orgasm or coming you can put pressure on them to perform the way *you* want them to rather than the way they find most satisfying. Maybe steer clear of orgasm-talk unless your partner comes easily and comfortably.

SOLO MASTURBATION. The advantages of sexual intercourse while hypnotized, namely lack of distraction, enhanced fantasies and complete focus on the activities at, er, hand, can also be quite effective as a result of post-hypnotic suggestion. Something like the following can be useful:

When you masturbate from now on, you will find that it'll become easier and easier to focus your mind on what you are doing, how you are touching and how you are stimulating yourself. You'll find yourself growing more responsive to your own touch, and you'll also find that your own masturbation will become more and more satisfying.

Your fantasies will be clearer and smoother, and you will find it more comfortable and natural for you to become involved with them and use them to increase you arousal and excitement.

At the same time, your increased focus on your own feelings and sensations will help you to exclude from your mind any distractions or worries or discomforts which might interfere with your enjoyment of what you are doing.

JOINT SESSIONS. If your partner is comfortable with the idea, you can also hypnotize them and then have them masturbate while you either watch or participate. The sort of participation that you should have in mind at this point is limited to an extra pair of hands helping your partner along. It's also not unlikely that your partner will find

extra excitement in being watched by you, and hypnosis could help them overcome their inhibitions enough to do it.

As your partner will be in a trance it is very useful to know whether they fantasize while masturbating and, if so, whether having you talking at the same time will distract them. Ask your partner: if they think that too much talk from you might interfere with their ability to concentrate or to fantasize, then try to limit yourself to just hypnotizing them, setting the scene and then letting them go.

WATCHING YOUR PARTNER MASTURBATE. Before you hypnotize your partner get them to prepare any toys they might want to use, have them undress and get them comfortably in their favourite masturbation position. Then hypnotize them, spend some time deepening the trance and then say something like the following. Feel free to adapt the script to your partner's use of toys (if any), their fantasies and so on:

On the count of three I want you to start masturbating. You will find yourself feeling sexy and responsive to the way you touch yourself. You will be able to move easily and change positions to accommodate the different things that you want to try.

You will stay in this trance while you masturbate and you will find it easy to respond, and also easy to do the things that help you to respond. Your hands will feel very good and your nerve-endings will all be alive and sensitive to the way you touch yourself.

You'll know that I am here watching you. You'll feel comfortable knowing that I'm here and this knowledge will serve to make you even more sexy and horny, more aroused and more responsive.

So, when I count to three you will start masturbating. You will be able to open your eyes if you need to to find your toys and to help you change position. You'll also feel comfortable and responsive knowing that I'm here with you and watching you.

OK. One... Two... THREE! Start masturbating now.

Watching your partner masturbate can be an excellent way to learn how they like to be touched. It is very likely that they will also enjoy the same touching when you do it.

Remember the debriefing after watching your partner masturbate. Find out what they were thinking and fantasising about.

PARTICIPATING WHILE YOUR PARTNER MASTURBATES. Helping your partner to masturbate has some great benefits. Firstly, you get to learn, by first-hand experience, how to touch them and what turns them on without having the the distraction of satisfying your own horniness[1]. This information will help you enormously in future love-making sessions.

Secondly, while you're helping them to masturbate, they have an extra pair of hands joining in, and therefore twice the number of nerve-endings get stimulated!

There are some key ideas to remember here:

1. You are there to help them get *their* rocks off, not yours. Your satisfaction is likely to be mainly intellectual.

2. "Guide my hands." Get them to show you what to do.

3. You're there to learn.

With these things in mind, let's look at a script. Your partner should be naked, in the "right" masturbating position, and hypnotized when you start:

I am sitting next to you now, and when I count to three I want you to start masturbating. I want you to focus on the sensations from your body and from the way you are touched.

I also want to you to know that my hands are here to help you. When it is appropriate I want you to show me or tell me how you'd like me to touch you. I don't want you to feel awkward about getting me to help you. I also don't want you to feel awkward about telling me to stop if and when you don't want me to touch you any more.

While you are masturbating I want you to be focused on achieving your own pleasure and your own satisfaction. When and if you fantasize, you will find yourself easily responding to the scenes in

1. *Difficult though this may be to achieve!*

your mind. Your mind and body will respond sensually and sexually and you will enjoy using your hands and your toys.

Focus on your own pleasure and feel free to get me to use my hands to make it even better for you. I don't want you to feel that you have to involve me. Do it only if it will increase your pleasure and satisfaction.

On the other hand you may find that you want me to do all the work while you lie back and enjoy the sensations that I give you. I want you to feel free to get me to do all the touching and I want you to feel comfortable telling me what you'd like me to do and not do.

So. On the count of three I want you to start masturbating.

One... Two... THREE!

This script is general. I'm sure that you could – and you should – adapt it to the specific ways your partner masturbates. Try not to make your partner feel obliged to perform in any particular way. The idea is to help them be free to do and experience whatever they need to have the best experience for themselves.

Note that one of the options the script gives your partner is that of letting you do all the work while they focus on the pleasure and sensations. Encourage them, but don't push them, to use this. What you learn when this happens will enrich your love-life considerably.

BDSM

THE myriad ways in which people accessorize sex is something that never ceases to amaze me. Now, while you may think that because I wrote this book I'm about as kinky as they come, I would consider myself as simply "liberal-minded." There are many fetishes and perversions out there which have no part in my own life but which I certainly don't in any way condemn. What happens between healthy and consenting adults is fine by me as long as it doesn't start treading the road to abuse.

While you might not have heard of it before there is a BDSM counter-culture spread fairly well world-wide. You might be a part of it, even without realizing it. BDSM is a clever little acronym that actually stands for three different things: *Bondage&Discipline*, *Dominance&Submission* and *Sadism/Masochism*.

1. *Bondage&Discipline* has to do with both (or either) restraining someone using handcuffs, rope, chains, etc. or chastisement with spanking, caning, whipping, etc. It is surprising in how many bedrooms you'll find things like handcuffs, blindfolds and maybe even gags, and how many people enjoy spanking!

2. *Dominance&Submission* has to do with *control* – with one person giving up control (submitting) and the other one taking it (dominating). Hypnosis can easily be seen to fit in here and many

people do simply find the giving up of control to their partner, via hypnosis or otherwise, to be highly erotic.

3. *Sadism/Masochism* involves the erotic uses of pain and discomfort. You may think this strange, but even such things as nipple-tweaking and tickling enter in here.

In this chapter I want to explore a little how hypnosis can be applied to *bondage*, *dominance* and *submission*.

BONDAGE. Bondage, in the BDSM sense, generally means restraining your partner in some way. Often this is done while they're naked and in such a way that some of the more interesting parts of their body are completely, er, "available." Handcuffs, chains, ropes, harnesses, slings and winches can be used to limit movement, and often give the "restrainee" a feeling of helplessness which they find very exciting.

Here are some ways you might like to explore restraining your partner hypnotically.

PARALYSIS. Paralysis is when the muscles stop working, i.e., they won't contract. Doing this hypnotically makes your partner rather like a rag-doll and leaves you free to position them how you want.

Very often your partner – once hypnotized – will be like this anyway (i.e., completely relaxed), but it doesn't hurt to remind them of how helpless they are:

On the count of three I'm going to make love to you and you'll be powerless to stop me. Your arms, legs and, indeed, your whole body will be completely limp and relaxed. You'll not be able to move at all regardless of how much you try. You'll know that I can do whatever I want with you and that you cannot stop me or resist me in any way.

You'll remain completely limp and helpless against me until I cancel this suggestion later, just before I wake you up. When I cancel this suggestion later you'll again be able to fully control your body.

One. Two. THREE!

Of course, once you finish with your partner you cancel the paralysis:

On the count of three your body – your arms, legs, etc. – will no longer be paralysed. Your body will again be under your control and the command I gave you earlier about being completely limp and unable to move will be cancelled.

One. Two. THREE!

BARBIE-DOLL-ISM. Another thing that you can do is have your own life-sized, anatomically-correct doll. Your partner will stay in whatever position your put them – bent over, standing, knees up, or however – for as long as you care to leave them that way. Keep in mind that your partner can never be *really* like a doll and that things like arms or legs left up in the air will eventually tire or get cramps. Also remember that while your partner might seem like a doll they are going to be as heavy as a human and that you'll have to haul them around.

On the count of three you'll become like a Barbie (or Ken) doll. You'll no longer be able to move your body yourself. Instead I'll be able to move your arms, legs, head, etc. into any position that I want and then they'll stay there just as if you were a doll.

You'll be a doll on the count of three and you'll remain in whichever position I place you. When I stand you up, bend you over, twist you, move your arms, head or legs, or whatever, you'll remain how I leave you.

You'll know that I'm in control, that you cannot move under your own willpower, and that no matter how hard you try your body won't respond to you. You'll know that I can do whatever I want with you, and that thought will be very exciting to you.

One. Two. THREE!

When you've finished with your partner (and I assume here, as an example, that your partner is standing up in some fashion):

Now, on the count of three you'll no longer be like a doll. Your body will be back under your control. When I reach three your body will be back under your control and I want you then to lay back down on the bed, relax and go back into the trance.

IMAGINED RESTRAINTS. Your partner might like, or be used to, being restrained by ropes or something similar. In this example I use a bit of imagery.

One the count of three you'll feel as if I have just tied you up with thick, soft rope. You'll feel the coils of rope around your body and arms, holding your arms tightly by your sides. At the same time you'll feel rope wound around your legs and tying your ankles closely together.

You'll feel the ropes holding you and binding you when I count to three. Then, afterwards as I continue to talk to you, you'll feel the ropes getting tighter, constraining you, holding you in the one position.

Now.... One. Two. THREE!

You can feel the ropes around you. You can feel the soft, thick rope pressing against your skin. You can feel it pulling your legs together, binding them tightly, with the rope pressing into your skin.

At the same time the rope around your arms and torso is getting tighter and tighter. It's like I am tightening it, adjusting it, denying you all possible freedom.

And when you're done:

On the count of three the ropes which are binding you will disappear. You'll be instantly free of the rope which you now feel on the count of three.

One. Two. THREE!

Ok. Relax now. The rope is gone. Relax and go back into a deep trance.

CLUMSINESS. Is hypnotic clumsiness a form of bondage? I'm not sure whether bondage fans would agree; however, with a good dose of imagination you can see that it does stop your partner from being able to do what they want. Maybe it's mainly just useful for fun.

Let's do this in the form of a post-hypnotic suggestion:

From when I wake you up from this trance, and until the end of today, you won't be able to fasten your bra or put on your panties. No matter how hard you try you won't be able to do up the clasps on your bra or pull up your panties.

For the rest of today your fingers just won't work and will be completely clumsy and impossible to coordinate when you try to put on your bra. The same will apply when you try to put on your panties: your fingers and hands won't work to let you pull on your panties for the rest of today.

This post-hypnotic suggestion will be completely effective up until the end of today. At the end of today this post-hypnotic suggestion will completely disappear, it will be cancelled, and you'll be able to put on your bra and panties again without any difficulty just like before.

SUBMISSION. Many people find it a turn-on to either take control of someone or to have someone take control of them. This can be the area of power-games. It isn't unusual for a younger female or male to be sexually attracted to an older, more dominant member of the opposite sex, particularly in power-sensitive environments like offices. It can be awkward, even confronting, for someone to accept that they either like taking control of their partner sexually, or that they like their partner to be in control sexually. In our modern society and culture "equality" is a key-word; actively seeking to *not* be equal to your partner can result in social censure and possible rejection.

Within the confines of a happy and satisfying relationship I believe that such inequality of control can be a healthy thing. Not everyone is the same; some are leaders, some are followers, and letting it happen is a way of simply being yourself.

By its very nature, hypnotizing your partner is asserting control over your partner. If this *control-taking* is what excites your partner, then you can orient your hypnosis sessions to emphasize control rather than straightforward sexuality or sensuality. If your partner is responsive to either taking control or giving up control but still feels inhibited – maybe they feel guilty but still feel a desire to do it – you can use post-hypnotic suggestion to help them feel more comfortable with these activities. Let us proceed to look at these:

UNDER CONTROL. So far in this book the style of phrasing that I've used in the various scripts has been cooperative and consensual. The emphasis was on working *with* your partner. When instead the goal of each session becomes simply taking control of your partner new phrasing and new exercises are in order. Consent is still important, but it becomes an issue of, "I agree to you taking full control and making the decisions," instead of, "I agree to this, this and this."

Taking control requires you to be assertive, authoritative and dominant. It needs to be – in your mind – that you are the one in control and that your partner is the one who obeys. You start this right at the beginning of the session with statements like:

I am going to hypnotize you now and there's nothing that you can do to stop it.

As you hypnotize your partner change the phrases that start with, "I want you to...", into simple imperatives – e.g., "Go into a trance now," "On the count of three open your eyes." Make the instructions that you give your partner as simple and short as possible. When you have your partner standing or walking around doing tasks, use simple, short, clipped commands like, "Sit!", "Stand!" and so on. There's no need to be angry or aggressive; just let them know that your way is the *only* way as far as they are concerned.

During the trance help them sink into their own feelings of being controlled by giving them suggestions like this:

During this trance and this session I'm in control. You'll do as I tell you and you'll accept that what I say goes. In your own mind accept that you're not in control any more. Sink into the surrender

*and your submission to me. Work towards, and focus on, doing
what I want you to do the best that you can. You'll feel pleasure
and satisfaction in knowing that you have given yourself as much
as possible to me.*

*Give your partner exercises and tasks to do for you. Have them
wash the dishes, clean the floors, tidy the lounge-room, wash the
car, iron your clothes and so on. Keep an eye on them, correct
them and reward them with praise for work well done. Don't be
flexible and don't debate with them–remember: your way is THE
way.*

RELEASING THE INHIBITIONS. As I've said before, the messages that
we get all through life from society, from friends and family tell us
how to behave. Unfortunately these messages don't always fit in 100%
with what we want or need, and going against this "ordained" behav-
ior can make us feel anything ranging from awkwardness to deep guilt
or shame. Feminism and machismo are also culprits. Post-hypnotic
suggestion can be useful here to relieve the inhibitions.

*In the future you'll find yourself feeling more comfortable with
the idea of taking control of me. Any awkwardness or guilt or
shame that you might feel about it will fade because you'll know
that it's something that we both want, and that it's something
that will be good for both of us.*

*You'll be comfortable exploring control with me, directing me,
telling me what to do and even simply just using me. It's what we
want to do together and it's something that will help us grow in
our relationship. You know that we both desire this: that I really
want you to control me, to be dominant to me, and that you
desire that control over me.*

*Each day it'll be easier and more natural for you to take control
over me. Each day you'll feel more comfortable with the idea,
and the guilt, awkwardness or shame will become less.*

On the other hand if your partner has trouble with giving up con-
trol, something like the following might be in order:

In the future you'll find yourself accepting your desire to be controlled by me. It'll become more natural and a comfortable thing to be controlled. You'll be able to sink into it more naturally as time goes on.

You'll feel safe with me, and you'll know that what we do together is our business. I want you to accept your desire to be controlled as part of you. It is nothing to feel bad or awkward about. It is something that will help you grow and feel complete within our relationship.

Role-Playing

MANY fantasies can be really, and I mean *really*, hot; and having a good time with a fantasy not unreasonably leads you into thinking: maybe that same fantasy would be even hotter in reality! Many couples work together to bring their fantasies to life; their bedroom, playroom or lounge-room becomes a theatre. The man may be a boring accountant during the day but at night he becomes – for an hour or two – Blackbeard the pirate, raping and pillaging from one side of the room to the other. His wife becomes a helpless female, captured from her village and subjected to Blackbeard's whims.

Role-playing lets you become someone else for a while. Maybe – if you're a man – someone stronger, more manly, more irresistible, even more "well-equipped." Women can become svelte models, prostitutes, Amazon princesses[1], stern teachers, helpless prisoners, famous athletes and so on. These roles let us escape from our own self-image for a while and become someone that we might like to be within the confines of the walls of our own home.

Combining role-play with hypnosis can allow your partner to become more deeply involved in their role, to experience it more deeply. It generally requires a number of things: it requires that your partner can go into a fairly deep trance because they are going to be *living* this role while they are still in a trance, and it requires that both you and

1. *Hopefully with both breasts still intact!*

your partner have good imaginations. Firstly you need a good imagination to help build the character for your partner, and then they need a good imagination to fill in or round out the character. It also requires a bit of theater.

The final thing that hypnotic role-playing requires is that you be experienced at working with your partner while they're in a trance. This is definitely not the sort of thing you want to try after you've hypnotized your partner just once or twice. You must be comfortable and sure about being in control. Trying to play your part as well as guiding your partner is really difficult. If you don't have the practice and the experience, the scene can end up simply falling apart with both you and your partner feeling frustrated (in more ways than one!) and wondering why the sparks didn't fly.

In the chapter on fantasies I gave a warning about frightening or scary scenes; I want to repeat the warning here. Avoid scenes and roles which can frighten your partner. Someone in a trance can become so involved in their role that things like imagined snakes, spiders, rape, heights and anything else potentially terrifying can *become* real with bad short- and long-term consequences.

The key to having a good role-playing scenario *work* is in the planning. It is far beyond the scope of this book to give you a complete script for each of the examples that I'm going to give. Instead I'm going to talk about preparations and help you with the words which can set the scene.

It's hard for even the best actors or actresses to enter a role in just an empty space. The more props they have that match the role, the more people they have around them whose behavior (role-playing) supports their own role, the easier it is for them to become their character. The same applies to you and your partner. Hypnotizing your partner and telling them that they are a French maid, for example, will work a whole lot better if they are dressed to suit. Or having them play a teacher will work better and they will be more involved if there is a blackboard or whiteboard present, a school desk or two, and you are dressed in school uniform.

Start planning your scene by deciding how the scene will start, where it will go and how it will play out at the end. This means physical

location, mood, sexual activities and feelings. Look at what turns each of you on, look at the props you have that might be useful, consider how long you have to play, and look at the space you have to play in.

Also look at both the character which you will play and that of your partner. It is important that you understand, if nothing else, the outline of these characters. It is not enough to say that your partner will be a teacher; you need also to say, for example, that the teacher is very strict, a disciplinarian, has had a shitty day because there's no coffee in the staffroom and that he is in *no mood* for any playing around in class.

The scripts and scenes that I describe below are here to give you ideas. You know your sex life, yourself and your partner far better than I, and I can't hope to discuss all the zillions of possibilities and combinations of tab A fitting into slot B here. Let the following serve as springboards for your imagination.

I always feel that ending a role-playing scene can be a bit ugly or rough if you do it by saying something like, "OK. That's it! The scene's over. Lie down, relax and go back into a deep trance." I much prefer to have a key-word, or trigger, that ends the scene. It avoids confusion and the prepares your partner for the end of the scene nice and early.

Sex Slave. Let's start with something simple and which requires very little in the way of preparation. The idea is that your partner is your sex slave, ready to serve and please you sexually in any way and at any time you choose.

The following script tells your partner that they will be your slave when you count to three, and that the scene will end when you say the word "conundrum." I'd suggest repeating the script a few times to your hypnotized partner before doing the count...

OK. I'm going to count to three in a moment. When I reach three you'll open your eyes and you'll no longer be Daphne, my wife; instead you'll be Selina, my obedient, energetic and enthusiastic sex slave. Your main goals in life will be serving me – touching me, massaging me, feeding me and attending to me in any way I wish, and being as pleasurable and as satisfying to me as possible.

You'll know that I own you, that you are my property. You'll be happiest when you know that I'm enjoying you, and when you're doing the tasks and duties I give you the best that you can. You'll find great pleasure and satisfaction in your service to me and in knowing that you are being used as a slave should be.

You'll be my deeply committed slave when I count to three and you'll remain my slave until I say the word, "conundrum." When I say the word, "conundrum," you'll no longer be my slave; you'll be Daphne – my wife – again and you'll sit down in your chair², close your eyes, relax and go back into a deep trance.

One... two... THREE!

SLAVE-MASTER/MISTRESS. I suppose that the opposite of having your partner be your sex slave is to have them be your master of mistress while they treat you as *their* sex slave. For those of you who don't find this a turn-on, I can assure you that there are many people out there who do find it either an exciting fantasy or an exciting reality to be *in service* to their partners from time to time.

The first script below puts your partner in the role of master – or mistress with a slight change of wording – with you as their willing slave. Of course, sometimes slaves aren't so willing or enthusiastic, so I have a second script later for a more authoritative and disciplinarian master.

As before I recommend repeating this script a number of times to your hypnotized partner before counting to three.

WILLING AND COOPERATIVE SLAVE.

Shortly I'm going to count to three. When I reach three you'll open your eyes and you'll no longer be my husband, Donald. Instead you'll be Derek, the firm, but patient, master of myself – your obedient and enthusiastic sex-slave, Jessica.

2. *Make sure that your partner understands, in this context, which chair you are refer-ring to.*

When I count to three you'll be my master and I'll be your slave. We'll no longer be husband and wife. Instead we'll be master and slave... and you'll be starting to feel the desire to make use of me sexually.

You'll have no hesitation in using me for your pleasure. You'll know that I am your property and that it is my place to be used by you as you see fit. You'll know that I'm simply slave and you'll feel comfortable directing and controlling me.

So. On the count of three you'll be my firm and strong master and owner, and you'll remain my master and owner until I say the word "conundrum." When I say "conundrum," you'll stop being my master and will return to being my husband, and I your wife, here in our bedroom. The scene will end when I say "conundrum," and you'll sit back down, close your eyes, relax and go back into a deep trance.

One. Two. THREE!

RECALCITRANT AND UNCOOPERATIVE SLAVE. You will notice that this script is remarkably similar to the previous script. Basically the personality characteristics of the "players" have been changed and there's a reference to "implements" – which you might like to expand to include rope, rulers, whips, canes, handcuffs[3] or whatever you happen to have lying around.

Shortly I am going to count to three. When I reach three you will open your eyes and you will no longer be my husband, Donald. Instead you will be Derek, the firm, strong and disciplinarian master of myself – your rebellious and uncooperative sex-slave, Jessica.

When I count to three you will be my master and I will be your slave. We will no longer be husband and wife. Instead we will be master and slave... and you will have decided to, and will, use me sexually.

3. *Note that some or all types of handcuffs may be illegal in your state or country.*

You will have no hesitation in using me for your pleasure. You'll know that I am your property and that it is my place to be used by you as you see fit. You'll know that I am simply a slave and you will not hesitate to use your strength, authority and whatever disciplinary implements are at hand to get your way with me.

So. On the count of three you will be my strict and strong master and owner, and you will remain my master and owner until I say the word, "conundrum." When I say "conundrum," you will stop being my master and will return to being my husband, and I your wife, here in our bedroom. The scene will end when I say "conundrum," and you will sit back down, close your eyes, relax and go back into a deep trance.

One. Two. THREE!

HOUSEMAID. Some people are turned on by cross-dressing – that's wearing clothes typically associated with their opposite sex. The *housemaid* role might be completely boring or a turn-off for women who already get enough of being a housemaid anyway, but some men are turned on amazingly by wearing female clothes and by performing "female duties," particularly when their partner is around and is telling them what to do. The following script is for these guys. A healthy supply of larger-size ladies' underwear – garter belts, stockings, bras and panties – and a French maid's uniform can go a long way with this one.

Ladies please note: If your husband displays an interest in this, run, do not walk, and start doing it as soon as possible! This can be a great way to get your house cleaned and have your sexual needs met in one fell swoop.

On the count of three you will open your eyes and you will be my maid, my housemaid. You'll know that you're not a woman, that you're a man, and that you are required to dress like a female housemaid to perform your duties around my house.

On the count of three you will be my housemaid and you will be ready and eager to perform your cleaning and tidying-up duties

around this house under my direction. You will be eager to get started, first by getting changed into your uniform, and then by dusting and cleaning the living room and finally by mopping the kitchen floor.

You will find it pleasant and sexually exciting to dress and work as a French housemaid for me. You will be happy to work under my direction... and you will continue to do so until I say the word "conundrum" to you.

When I say that word "conundrum" to you, you will no longer be my housemaid; you will be my husband again. You will stop what you're doing and then you'll sit back down in your chair, close your eyes, relax and go back into a deep trance.

So. On the count of three you will be my enthusiastic, cross-dressing housemaid and you will work for me until I say the word "conundrum," at which time you will stop being my housemaid and you'll sit back down and go back into a trance.

PRISONER CAPTURED BY A PIRATE. Whenever I think of a prisoner captured by a pirate I think of someone tied to the mast of a pirate's sailing ship. They're maybe flogged first before the evil captain cuts away their clothes and then... we go to a commercial break.

It's hard to fit a pirate ship into your bedroom, but you can improvize by attaching your partner – maybe bent over – to something like a chair. You might also like to ensure that they're wearing cheap, worn-out clothes that you can actually cut away[4] during the scene for a bit more realism and intensity. I'd suggest that you start the scene with your partner already in place, i.e., you first hypnotize your partner deeply, have them move into position, then you restrain them however you've decided.

In this script I have included a *safe-word*. This is a way for your victim/partner to let you know if something starts going wrong. Basically it's a word that they can say which lets you know to stop and find

4. *You should learn a bit about bondage from a good book or class first. And. of course, be very careful with sharp scissors or knives!*

the problem (e.g., a cramp, numbness due to bad circulation caused by tight ropes, etc.) Words like "Stop!" or "Help!" aren't useful because your partner might yell them anyway as part of the role. Of course, safe-words won't work if they're gagged and you'll have to invent some *safe-gesture* instead.

On the count of three you will open your eyes and you will be my prisoner on my pirate ship. I will be the evil and cruel pirate Specklebeard. You are tied so that you cannot escape and I will flog you first, then rip off your clothes and have my evil and sexual way with you.

You will be my prisoner on my pirate ship when I count to three, and you will struggle and curse and fight as hard as you can — even though you are tied up — as I flog you and take you sexually.

I want this to seem almost completely real to you, but I also want part of you to know that this is a scene we are playing. If, at any time, you are in real distress or panic, whether it's emotional or physical, I want to you say the word "red" as loud as you can to let me know that there is a problem.

I will count to three in a moment, and when I do you'll open your eyes and you'll be my prisoner on my pirate ship.

One. Two. THREE!

STRIPTEASE DANCER. I love the idea of my partner doing a striptease dance for me. Good preparation for this is an appropriate piece of music ready-to-play and also includes making sure that your partner is wearing clothes that can be removed easily. Clothes with a zillion buttons or hooks, or shoes that require meticulous unlacing to remove, will only slow down the pace. Like always, repetition before counting to three will help you get a good result.

I'm going to play the song "Love Potion #9" in a moment. When you hear it you'll open your eyes, you'll be a sexy striptease dancer and "Love Potion #9" will be your song. You'll get up and straight away start doing your sexiest striptease dance just for me.

As soon as you hear the song you'll open your eyes and do your sexiest, hottest striptease dance just for me. You'll find me very, very sexy and it'll be exciting to dance for me. You'll feel so sexy and horny as you dance and by the time the song ends and you're completely naked you'll be so hot and hungry that you won't be able to keep your hands off me.

You'll do a very sexy striptease dance when I play "Love Potion #9" in a moment and, at the end of the song, you'll feel so horny and hot that we'll make passionate love together. When we finish making love you'll lay on your back, make yourself comfortable and then close your eyes and go back into a deep trance.

One. Two. THREE!

GENERIC ROLE-PLAYING POST-HYPNOTIC SUGGESTION. Sometimes you might just want it to be easier for your partner to get involved with all the roles that you play together rather than use hypnosis for every single scene. Voila! Here's a post-hypnotic suggestion script which you can try. Give your partner this PHS from time to time and then role-play as usual.

In future you'll find it becomes easier and easier to become involved and immersed in our sexual role-playing games. Each time it'll become more natural to ignore the outside world and become the role that you're playing.

Any worries or problems that you have in your day-to-day life will fade away while we're playing in our bedroom – there will just be us and what we're doing. Your imagination will flow freely and you'll be able to enter into role you play smoothly and naturally and without effort.

You'll be able to participate in our role-playing games without feeling so embarrassed, shy or inhibited. Each day you'll open up more and more to our sexual games and roles, and each day your imagination will fire more and you'll feel more than during the times before.

Conclusion

HEY, great! You made it this far!... Hmmmm. You didn't just jump to the end to see how the story ends, did you?

There's nothing magical about hypnosis. Looking back over the last twenty years or so of movies, magazines and popular books, I really have hope that the days have gone when hypnotists tried to convince people that they were endowed with some mysterious power that let them control others.

Hypnosis is not an end in itself. It is a tool. It is a way of achieving things. You can use it to learn to concentrate better, to help your memory, to meditate, to help you quit smoking or to help you develop good habits... and you can use it to focus yourself and your partner on sex and to do explorations which might otherwise be much more difficult.

Sex is a great invention. You gotta wonder how we used to get along without it! Of course Mother Nature didn't exclusively design it for earthshaking orgasms – its primary purpose was to bring little bundles of joy into the world. These days, though, decent condoms and the Pill have allowed us to make it much more recreational.

Dildoes, vibrators, silk underwear, handcuffs, chains, stocks, whips... er, sorry, where was I? Ah, yes. Dildoes and the like are toys which manipulate the body. Role-playing games and dressing-up hint

at playing with the mind. It is the mind that makes things sexy, and with hypnosis you are going direct to the source of all that horniness. No messing around with trying to set the scene by indirect means such as dim lights, a bit of the bubbly and appropriate music. With hypnosis you set the scene and create the mood with your words; with a responsive partner they're there almost right away. Hypnosis is also often about vulnerability and control, and these are both things that many people find very sexually exciting.

As with all things that develop depth and meaning for the partners involved, using hypnosis and developing the trust and techniques that work for you takes time, openness, honesty and good communication. In turn hypnosis and the explorations you find through this book provide opportunities for and encourage this openness, intimacy and discussion of feelings and desires.

Ancient alchemists used chemical compounds and processes which they had discovered by often by accident to work their wonders. In their ignorance they developed their own strange theories of why their techniques worked but they didn't really understand. If, in this book, I just gave you a series of instructions to follow or a series of scripts to read then I would be basically giving you alchemy – you most likely wouldn't have the background to understand how the words are meant to work.

I want this book to serve as a starting point for you. That's why there are all the explanations and all the hints. I want you to have a good grasp of what is going on and how the various techniques have their effect so that you can take what I've given you here and intelligently adapt it and grow it to suit you and your partner.

Hypnosis and sex go well together. I love the combination and I hope you do too.

Further Studies and Resources

I T'S very difficult to find any literature that seriously tries to tie hypnosis and sex together. About the best you can usually do are clinical papers on hypnosis and sex therapy or sexual dysfunction. I find that I can only really recommend one book. It's an excellent book on hypnosis and is a very pleasant and fascinating read. If you're looking for a good and general understanding of most aspects of hypnosis then this is the place to look.

The Practice of Hypnotism
Second Edition
André M. Weitzenhiffer
©2000
ISBN 0-471-29790-9
John Wiley & Sons, Inc.

Most countries have professional hypnotherapist societies offering training (although it's usually expensive), books and videos. Indeed, many countries have a plethora of such organisations focusing on the needs of different practitioners such as dentists, doctors, therapists, etc. Although I expect few readers to be interested enough to pursue professional training – even if just at a basic level – it is an excellent way to learn the do's and don'ts and, who knows?, you might be able to make a career out of it.

Here is a small handful:

American Society of Clinical Hypnosis
130 E. Elm Court, Suite 201
Roselle, Il 60172-2000
Phone number: 630/980-4740
FAX number: 630/351-8490
WWW: http://www.asch.net/

British Society of Clinical Hypnosis
WWW: http://www.bsch.org.uk/

Canadian Society of Clinical Hypnosis
WWW: http://www.csch.org/

About The Author

Peter Masters is primarily a teacher, sports instructor, computer geek and writer. He has been interested in hypnosis since his early teens. To make sure he fully appreciated it and got it "right" he studied for and achieved a diploma in clinical hypnotherapy by the time he was 20. Although these days he doesn't directly use his qualification in any of his professional activities, he still tries to keep his hand in, and to stay in touch with the current literature and developments.

This book is the result of both research, and of private-life exploration over the last twenty years with a variety of partners. Like most of his projects it started out as a way of finding and filling in the gaps in his own understanding. With any luck he hopes to bring an air of rational understanding and practicality to a topic which has too often been seen as akin to magic.

IF YOU LIKED *LOOK INTO MY EYES,*
YOU MIGHT ENJOY:

GENERAL SEXUALITY

Big Big Love: A Sourcebook on Sex for People of Size and Those Who Love Them
Hanne Blank $15.95

The Bride Wore Black Leather... And He Looked Fabulous!: An Etiquette Guide for the Rest of Us
Andrew Campbell $11.95

The Ethical Slut: A Guide to Infinite Sexual Possibilities
Dossie Easton & Catherine A. Liszt $15.95

A Hand in the Bush: The Fine Art of Vaginal Fisting
Deborah Addington $11.95

Health Care Without Shame: A Handbook for the Sexually Diverse & Their Caregivers
Charles Moser, Ph.D., M.D. $11.95

Sex Toy Tricks: More than 125 Ways to Accessorize Good Sex
Jay Wiseman $11.95

The Strap-On Book
A.H. Dion, ill. Donna Barr $11.95

Supermarket Tricks: More than 125 Ways to Improvise Good Sex
Jay Wiseman $11.95

Tricks: More than 125 Ways to Make Good Sex Better
Jay Wiseman $11.95

When Someone You Love Is Kinky
Dossie Easton & Catherine A. Liszt $15.95

BDSM/KINK

The Bottoming Book: Or, How To Get Terrible Things Done To You By Wonderful People
D. Easton & C.A. Liszt, ill. Fish $11.95

The Bullwhip Book
Andrew Conway $11.95

A Charm School for Sissy Maids
Mistress Lorelei $11.95

The Compleat Spanker
Lady Green $11.95

Flogging
Joseph W. Bean $11.95

Jay Wiseman's Erotic Bondage Handbook
Jay Wiseman $15.95

Miss Abernathy's Concise Slave Training Manual
Christina Abernathy $11.95

The Mistress Manual: The Good Girl's Guide to Female Dominance
Mistress Lorelei $15.95

The Sexually Dominant Woman: A Workbook for Nervous Beginners
Lady Green $11.95

SM 101: A Realistic Introduction
Jay Wiseman $24.95

The Topping Book: Or, Getting Good At Being Bad
D. Easton & C.A. Liszt, ill. Fish $11.95

Training With Miss Abernathy: A Workbook for Erotic Slaves and Their Owners
Christina Abernathy $11.95

FICTION FROM GRASS STAIN PRESS

The 43rd Mistress: A Sensual Odyssey
Grant Antrews $11.95

Haughty Spirit
Sharon Green $11.95

Justice and Other Short Erotic Tales
Tammy Jo Eckhart $11.95

Love, Sal: letters from a boy in The City
Sal Iacopelli $11.95

Murder At Roissy
John Warren $11.95

The Warrior Within (part 1 of the Terrilian series)
Sharon Green $11.95

The Warrior Enchained (part 2 of the Terrilian series)
Sharon Green $11.95

Please include $3 for first book and $1 for each additional book with your order to cover shipping and handling costs, plus $10 for overseas orders. VISA/MC accepted. Order from:

 greenery press

1447 Park St., Emeryville, CA 94608
toll-free 888/944-4434 http://www.greenerypress.com